IMAGES
of America

THE FONDA, JOHNSTOWN, & GLOVERSVILLE RAILROAD
SACANDAGA ROUTE TO THE ADIRONDACKS

IMAGES
of America

THE FONDA, JOHNSTOWN, & GLOVERSVILLE RAILROAD
SACANDAGA ROUTE TO THE ADIRONDACKS

Randy L. Decker

ARCADIA

First printed in 1998.
Reprinted in 2000, 2003.

Published by Arcadia Publishing,
an imprint of Tempus Publishing, Inc.
2 Cumberland Street
Charleston, SC 29401

Printed in Great Britain.

Library of Congress Catalog Card Number: 98-87872

For all general information contact Arcadia Publishing at:
Telephone 843-853-2070
Fax 843-853-0044
E-Mail sales@arcadiapublishing.com

For customer service and orders:
Toll-Free 1-888-313-2665

Visit us on the internet at http://www.arcadiapublishing.com

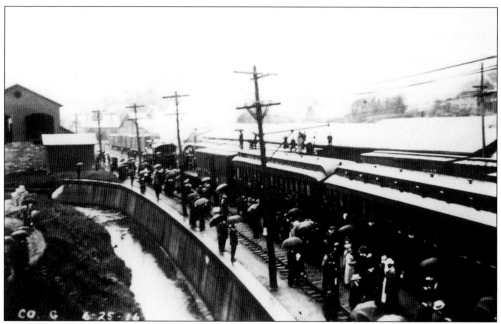

OFF TO WAR. The FJ&G Railroad did its part for the war effort during World War I. Here Company G is saying their farewells to family and friends in the Gloversville yards before heading off to war in Europe on June 25, 1916.

CONTENTS

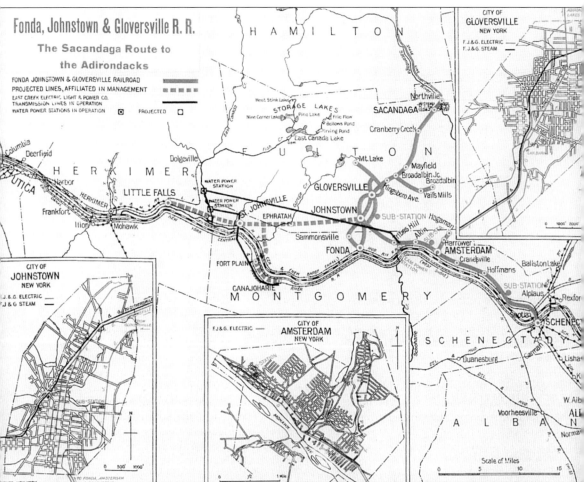

THE STEAM AND ELECTRIC DIVISIONS OF THE FONDA, JOHNSTOWN AND GLOVERSVILLE RAILROAD, 1910. Shortly after the turn of the century a person could travel throughout the East Coast and across the country while riding in an electric interurban, encountering only one break in service while traveling through the scenic Mohawk Valley of New York state. Oddly enough, the area between Fonda and Little Falls had the distinction of being the only section of the country that was never electrified by a major railroad or short line. On this map there is evidence of an attempt made by the Fonda, Johnstown and Gloversville Railroad and investors from Little Falls to bridge this last gap. Surveys were made and stocks were sold but difficulties in purchasing affordable land eventually halted the project.

ACKNOWLEDGMENTS

While growing up in Gloversville, New York, during the 1960s, I spent many hours playing (unbeknownst to my parents) along the railroad tracks of the Fonda, Johnstown and Gloversville Railroad. The railroad was not far from my home, and I was often joined there by neighborhood friends and my older brother, Lewis, who was given specific instructions to keep me away from the trains—sorry, Lew! I remember well the brightly striped Alco diesels #21 and #22, and from time to time I even caught a glimpse of #30, a GE 44-tonner with its cab oddly in the center. While working to keep the railroad alive, these noisy diesels flattened many of Uncle Sam's Lincoln-head pennies! I also remember John Wayne (or was it Clint Eastwood) and their many attempts to capture the railroad meager deliveries almost every day in the early 1970s,took one of those trains almost every day, between the North Street and Eighth Avenue crossings.

Born well into the diesel era, I have to thank every previous railroad enthusiast who had the foresight to preserve the great photographs of the railroad that exist today. A special thanks goes out to Ira Barnes, who carried a camera during the steam era and captured many of the images used in this book. I would also like to thank another railroad enthusiast and historian, Glen Cady, whose photo collection and in-depth knowledge of many railroads, including the FJ&G, helped spark my interest in railroad lore. Railroad historians David Nestle and Walt Danalac were of great help to me and answered many tedious questions about this railroads great history. Of course, I wish to thank my father, Lewis G. Decker, the Historian for Fulton County. His advice and lifelong interest in local history have given me an understanding of the importance, as well as the enjoyment, of accurately preserving the past. I would also like to thank my brother, Lewis Decker Jr., who also shares my interest in railroads and is always an enthusiastic companion in the pursuit of railroadiana.

This book is in the second printing and with it comes the opportunity to get it right! I would like to thank my wife Lorraine, who has helped with my persistant mutations of the written language and has helped me to find valuable time, diligently keeping our two beautiful daughters, Emmalee and Megan, occupied and away from the large and tempting piles of carefully sorted photographs and information.

There were many local people who I have contacted through the years concerning the FJ&G RR. This list is endless and continues to this day. I would like to thank all of these people by letting them know that my collection and knowledge will be openly shared with other historians and authors in the future. I sincerely hope this book will be used as a historical reference as well as an enlightening source of entertainment. Enjoy!

—Randy Lee Decker

INTRODUCTION

After the Civil War, our nation began refocusing its attention on geographically and monetarily uniting the country. Steam railroads, by design, were accomplishing this task at breakneck speed. At that time in America's history, most of the larger railroad companies had begun crisscrossing the entire country with steel rails; in the process, they connected the larger cities, opening up their massive industries, endless products, and potential customers. Many small communities, after connecting with one of these major railroads, began enjoying new prosperity and growth. The creation of new jobs, the access to new, seemingly limitless marketplaces, and the means to transport products as well as passengers at high speeds anywhere in the country were just a few of the benefits enjoyed by the railside communities. The railroads could put a small city on the map virtually overnight.

With this in mind, business owners and prominent citizens from the southern Adirondack region of Fulton County, headed by Mr. Willard J. Heacock, one of the county's principal glove manufacturers, decided they would like to share in the wealth and endless opportunities inevitable through a connection with the New York Central and Hudson River Railroad at Fonda, New York. Stocks were sold through the persuasive efforts of Mr. Heacock, and in January of 1867 the FJ&G Railroad Co. was formed. Construction commenced in September of that year, and by 1870, with the aid of Mr. Lawton Caton, another influential figure in Fulton County history, the rail line from Gloversville to Fonda was finally completed. An official opening took place on November 29, 1870, with the arrival of the first train to reach Gloversville, pulled by the company's first engine, appropriately named "The Pioneer."

With future plans to build a railroad farther north into the Adirondack Mountains, following the Sacandaga River, prominent men from the village of Northville and the Mayfield area as well as some of the principal investors from the FJ&G Railroad formed the Gloversville and Northville Railroad Co. Construction began in 1872 and on November 29, 1875, five years to the opening day of the FJ&G Railroad, a passenger train arrived at the Northville station, 16 miles to the north of Gloversville. Shortly thereafter, the Gloversville and Northville Railroad Co. was purchased by the FJ&G through a foreclosure from a failure to pay stock interest. The official foreclosure took place on January 31, 1881, and increased the FJ&G Railroad's track length from 10 to 26 total miles.

In the mid-1870s, the FJ&G Railroad Company purchased more than 700 acres of land just south of the station at Northville; the area was already a popular religious campgrounds, and the company spared no expense to develop it into a beautiful Adirondack resort called "Sacandaga

Park." After the acquisition of the Northern Division, the FJ&G began an unprecedented period of growth and prosperity. By the late 1880s, the railroad owned 7 locomotives, 9 passenger coaches, 3 express and baggage cars, and 30 box and platform freight cars. In 1888, two new massive passenger stations were built in Gloversville and Johnstown and many freight and storage structures were built throughout the line. At this time, improvements were being made to the roadbed, steel rail, bridges, and sidings, and in Gloversville new equipment was purchased for the locomotive shop. At this repair shop, under the direction of master mechanic Mr. George V. Putman, locomotives from other railroads were refitted or repaired. A shop of this ability was unheard of on a smaller railroad and it was a great source of pride as well as revenue for the company.

In the early 1890s, the community of Broadalbin, 6 miles to the east of the FJ&G line, had been trying to connect itself to the NYC&HR Railroad to the south at Amsterdam. In April 1895, this endeavor was abandoned and the formation of the Gloversville and Broadalbin Railroad, with designs to connect with the FJ&G just north of Gloversville, was commenced. In August of that same year the line was completed. Like the G&N Railroad, equipment from the FJ&G was used to construct and operate the G&B Railroad, and a permanent lease was drawn up for the operation of the branch railroad by the FJ&G. During construction a small passenger shelter was built at Vails Mills, just west of Broadalbin, and a very ornate passenger station was built in the village of Broadalbin by the Husted family for use by the community as well as the railroad. This last addition to the Steam Division increased the FJ&G's total length to 32 miles.

Throughout this period the only real competition the steam line faced came in the form of an electrified railroad called the Cayadutta Electric Railroad, built from Fonda to Johnstown and into the southern outskirts of Gloversville in 1893. This small electric railroad had purchased the controlling stock of the Johnstown, Gloversville and Kingsboro Horse Railroad, which had been quietly running throughout Gloversville and Johnstown since 1873. The Cayadutta conducted a successful freight and passenger operation in direct competition with the FJ&G. This competitive-minded railroad even constructed a small outdoor picnic area called "The Cayadutta Park," complete with rustic bridges and pavilions, approximately one mile north of Fonda to compete with the FJ&G park at Sacandaga. It was not long before the FJ&G and the Cayadutta Electric began fighting for control, and through stock purchases and transfers the Cayadutta Electric Railroad eventually bought the controlling interest of the Fonda, Johnstown and Gloversville Railroad. The FJ&G retained its name and the Cayadutta operated as the company's "Electric Division" from 1894 on.

During the period between 1873 and 1890 a horse-powered railroad had also been quietly operating in Amsterdam. In 1890 this street railroad was electrified and for a short time it operated as the Amsterdam and Rockton Street Railway Co. In 1891 an electric car was successfully operated up the 14-percent grade of the Market Street hill in Amsterdam. This grade was considered one of the steepest in the country at that time. By 1901 the controlling interest in the Amsterdam Street Railway was also under the FJ&G Railroad's control. In the summer of 1902 the company's "Amsterdam Division" constructed a line into Hagaman (north of Amsterdam); later that year a double-track extension from Sulfer Springs Junction to Amsterdam was underway, and a single-track connection between the two railroads opened in January of 1903. During 1903 the double-track line was finished from Johnstown to Amsterdam and on through the scenic Mohawk Valley to Scotia, crossing the Mohawk River into Schenectady. The FJ&G Railroad's impressive new Electric Division was powered by a massive steam-powered electric generating plant built in Tribes Hill that supplied 13,000 volts to three substations, which in turn converted the electricity to 600 volts DC.

At the same time the FJ&G was extending their electric line to Schenectady, another small electric railroad to the north of Gloversville, originally named the Mountain Lake Electric Railroad, was having serious financial difficulties due to a disastrous wreck in 1902 that killed 14 people. Like all the other railroads and businesses that caught the eyes of the Fonda, Johnstown and Gloversville Railroad, this small railroad, and the amusement park it was built

to serve, were purchased in 1904 by the FJ&G. This ended the railroad's expansion, with a combined Electric and Steam Division roadbed of 132 miles.

Throughout the early 1900s the FJ&G continued to see increased profits. Railroads set the standard for travel and in 1903 the FJ&G set the standard for every short line in the nation when it exclusively purchased 12, specially designed, heavy interurbans, finished in dark green paint with gold trim, boasting a smooth ride, plush seats, a smoking section, an ice-cooled water fountain, a hot water heating system, toilets, and a solid mahogany interior, for an unheard of $14,000. The company also purchased many of its steam engines and coaches from the best locomotive shops and car builders in the country at that time. At Sacandaga Park a miniature steam engine ride was introduced and with the advent of electricity dozens of attractions and amusements as well as lighting throughout the park ushered in a new era. This was the heyday of the railroads and everyone was busy enjoying the prosperity and conveniences of the changing times. Almost no one took notice of the slow but persistent horseless carriages that were struggling along on poorly kept dirt roads near the railroad tracks.

It was after the First World War that the railroads began feeling the first effects of the meliorating automobile. Unlike the roadbeds of the privately owned railroads, tax dollars were used to improve the automobile roadways throughout the nation. Everyone was finding a new freedom, traveling into areas untouched by the railroads and never worrying about a time schedule while doing so. On the FJ&G the Mountain Lake section was closed, due in part to the popularity and improvements at Sacandaga Park, and fares began to be reduced across the board. In 1922 the railroad purchased three gasoline-powered cars (the first of their kind in New York) to help compete with the automobile and reduce costs on the Northville run to the park.

In 1930 the State of New York finished the construction of a massive earthen dam and power plant at Conklingville to regulate the waters of the Sacandaga River, creating "The Great Sacandaga Lake," the Northeast's largest man-made reservoir. Many communities as well as sections of the railroad were permanently covered by several feet of water. This marked the end of the Northern Division; trucks and buses began to service the communities lost to the lake. The year 1930 also marked the last steam passenger service on the line except for a daily mixed train that ran to Broadalbin. From this point on the FJ&G had incorporated buses to carry passengers throughout all areas served by the railroad. In 1938 the Electric Division was abandoned, and gas electric car #340 was purchased to continue express mail service to and from Fonda. Still struggling to survive, the FJ&G became one of the first railroads to use diesel power. In 1945 it purchased the first of two Alco S-2 1,000-hp diesels, numbered 21 and 22. These diesels continued to serve the dwindling needs of the railroad for 40 more years. Sadly, the last steam engine, #14, met with the scrapers torch in 1956, and the mixed passenger train to Broadalbin was run for the last time.

By the 1960s the railroad offices had been moved from the Gloversville station to the freight offices in the yards across the street and freight service to Broadalbin was discontinued. In September of 1969 the passenger station in Gloversville burned, and five years later, after more than 100 years of service, the Fonda, Johnstown and Gloversville Railroad was sold to the Delaware and Otsego System. Under the direction of Mr. Walter Reich and government funding, the railroad continued to operate for 10 more years. In November of 1984 the last train was run behind Delaware and Otsego diesel #103. Sadly, any possibilities of resurrecting the FJ&G were destroyed when, in 1990, the dormant but intact railbed was removed and any salvageable equipment scraped by the county.

One
THE FJ&G RAILROAD'S STEAM DIVISION

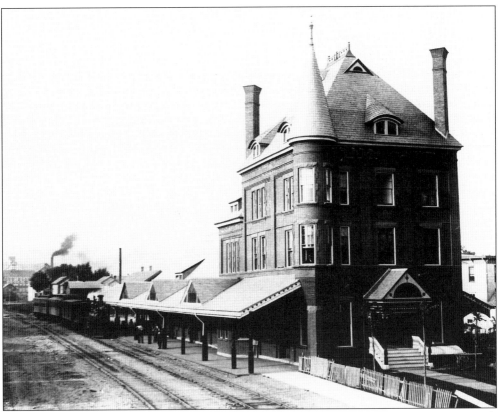

GLOVERSVILLE'S THIRD PASSENGER STATION SOON AFTER CONSTRUCTION IN 1888. A second-floor addition costing $11,500 was added in 1902, bringing the grand total for this, the largest station, to $37,000. The third floor of this station was used as the main office and residence for the railroads superintendants through the years.

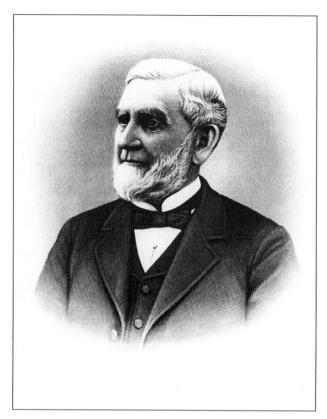

MR. WILLIARD J. HEACOCK, CONSIDERED THE FOUNDING FATHER OF THE FJ&G RAILROAD CO. Mr. Heacock vigilantly pursued the financial backing of many local businessmen and prominent citizens in the 1860s to facilitate the future construction of a railroad connection with the NYC&HR Railroad. This was considered a risky investment in the sparsely populated area of Fulton County, New York.

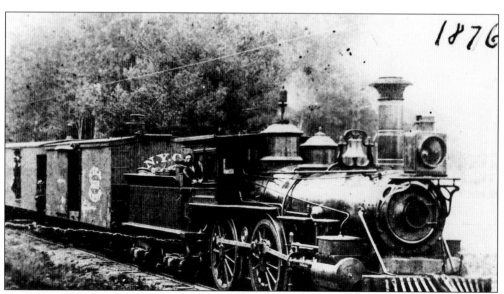

THE PIONEER. This is the railroads first engine #1, hauling box freight. It was later rebuilt and renamed the David A. Wells; during a third rebuilt, the name was dropped. This is how the "Manchester" engine appeared until it was sold in November of 1889. The date on this photograph appears to be correct.

12

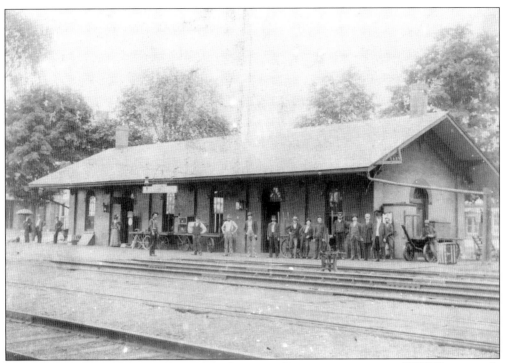

AN EARLY PHOTOGRAPH OF THE FONDA STATION, LOCATED ALONG THE NYC RAILROAD'S RIGHT-OF-WAY. This photo was taken before any additions were added to the original brick structure.

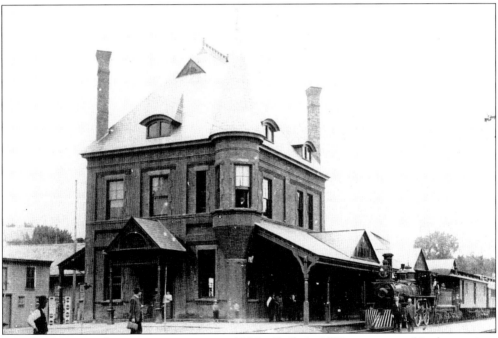

THE JOHNSTOWN STATION IN THE LATE 1890s. Built in 1888 as a copy of its larger sister station in Gloversville and costing the same amount to construct, this station served Johnstown well with its Victorian grandeur until a fire destroyed it on March 17, 1926.

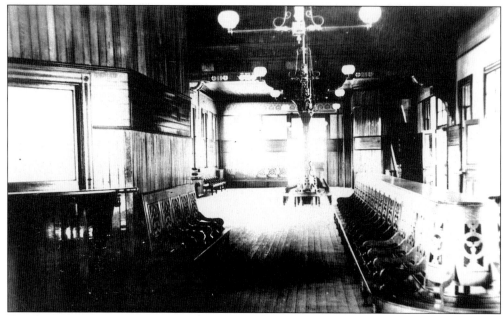

THE JOHNSTOWN STATION. You could be looking inside either station in this photo, but this shot is identified as the Johnstown station.

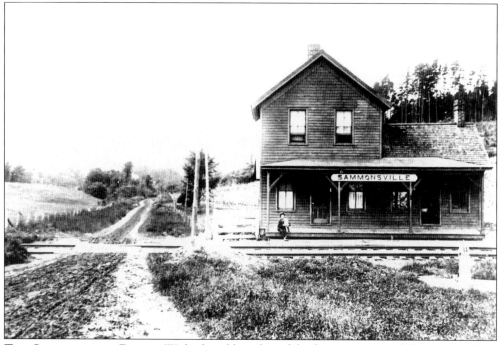

THE SAMMONSVILLE DEPOT. With the old trail road leading west toward Sammonsville, a young boy poses for a picture on the porch of the second Sammonsville depot, constructed in 1886, approximately 4 miles north of Fonda.

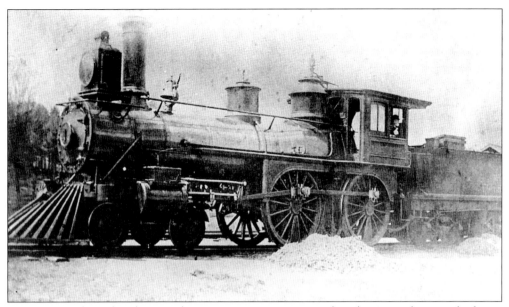

ENGINE #1. The railroad's second American-type engine numbered "1" was photographed near Northville in 1889 with the wife of engineer Frank Robinson in the cab.

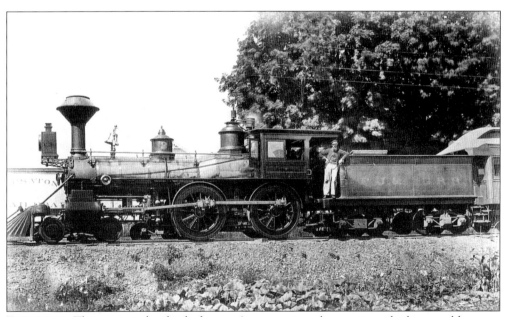

ENGINE #2. This engine, the third of many American-type locomotives the line would own, is shown here *c.* 1890 with engineer Mr. Quinby, whose whiskers trailed out of the cab window as the engine thundered by.

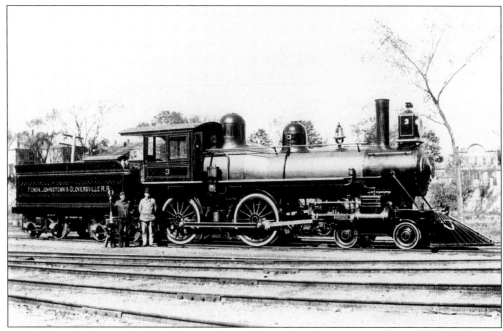

TWO SHOTS OF ENGINE #3 IN GLOVERSVILLE. These two views show some obvious differences. In the upper photo #3 is sporting a solid rimmed lead truck, no visible front coupler, no marker lamps, no whistle, and an early box-type oil lamp. It is possible that the locomotive shop could have made these changes. The steam whistle in the lower photo was reportedly installed (note the modification to the bell also) in May of 1898 by the FJ&G as a new safety feature.

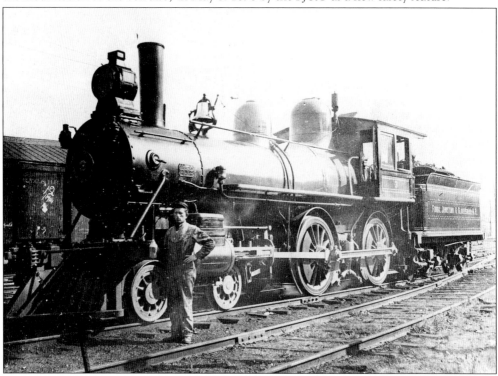

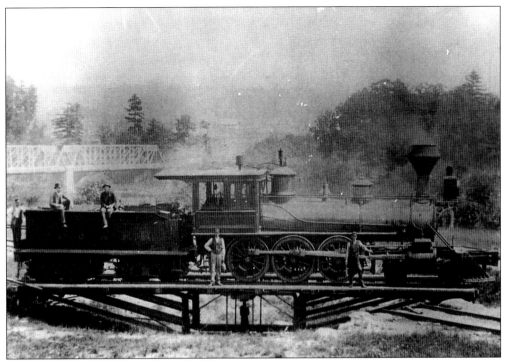

THE WILLIARD J. HEACOCK. This early 10-wheeler's number has been difficult to trace. At the time, this engine was the largest the FJ&G purchased and was orginally called the Williard J. Heacock. It was later known as the first of two #3's.

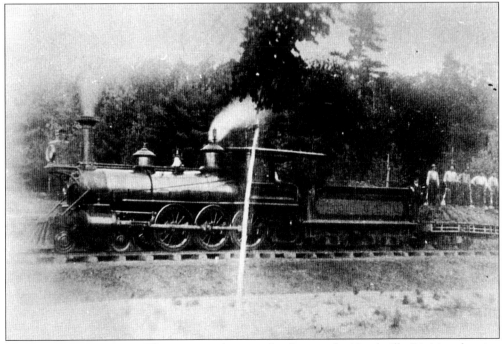

THE SECOND ENGINE #4. This is a rare photograph taken on the Northville Division showing ballasting operations using sand and shovels to improve the northern section in 1876.

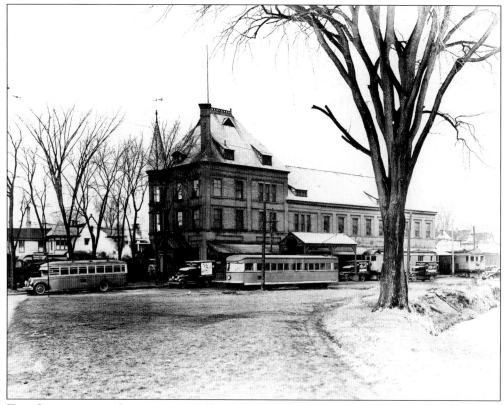

THE GLOVERSVILLE STATION, WITH ITS SECOND FLOOR COMPLETED. This view shows the FJ&G Railroad's great diversification. If you look closely behind the bus you will see #11 letting off steam. Those elm trees have grown some since they were planted.

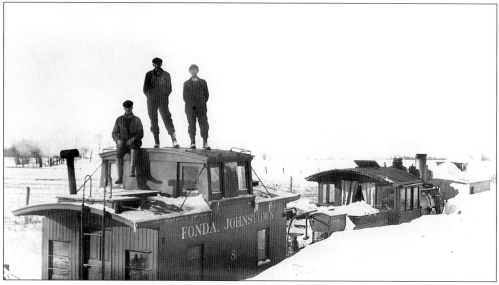

AN FJ&G ENGINE CREW ATOP CABOOSE #2. This crew posed for a photograph after becoming hopelessly buried in drifting snow near Sammonsville on March 14, 1920. The snow drift suspended railroad traffic for 32 hours.

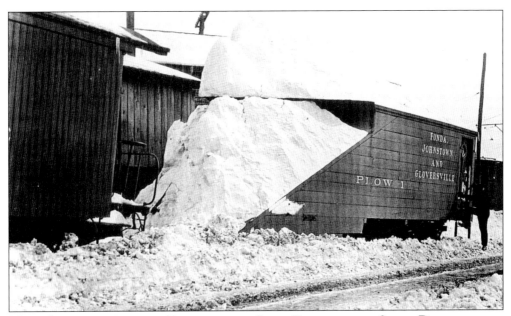

Wood Snowplow #1 after Fighting with Snow Drifts on the Steam Division, near Sammonsville, in 1920.

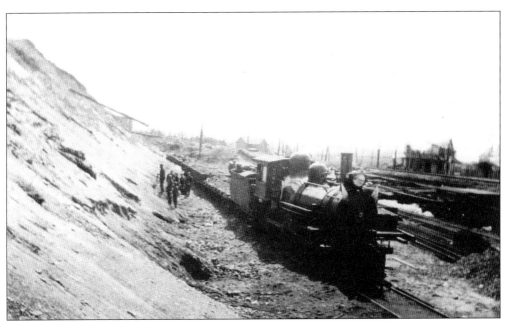

Engine #3 on a Work Detail, Loading Ballast from the Sand Bank near Hill Street in Gloversville, c. 1900.

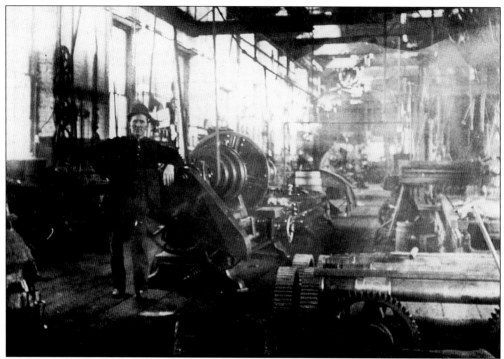

A VIEW INSIDE THE LOCOMOTIVE SHOP LOCATED ON WEST FULTON STREET IN GLOVERSVILLE. The FJ&G purchased the best lathes and machining tools available to repair their own equipment, as well as locomotives from other railroads in need of this service.

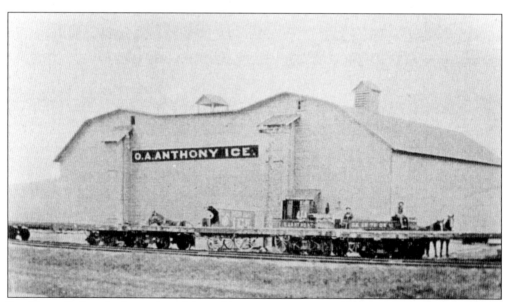

ICE COLD. Before the invention of the refrigerator everyone used block ice throughout the year to keep foods cold. Orrin Anthony's Ice House, near the Kingsboro Station, was one of the largest storage houses for block ice in the area. It supplied the ice used by the railroad.

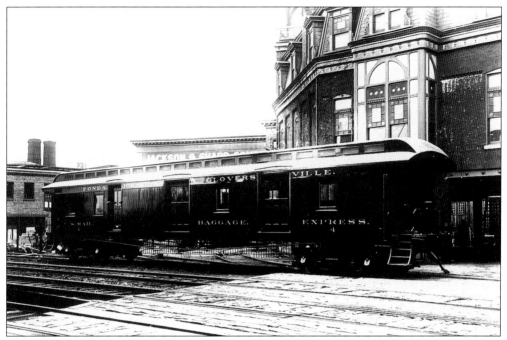

BAGGAGE CAR #4. An RPO express, built for the FJ&G Railroad, is shown here in Wilmington, Delaware, before delivery from the car building shops of Jackson & Sharp.

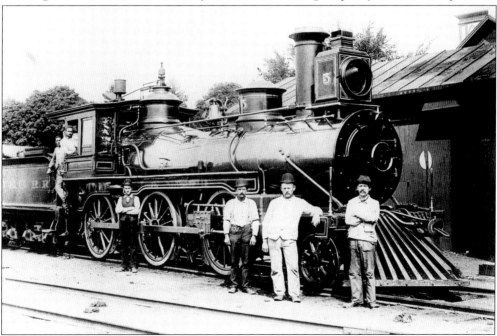

ENGINE #5. Taken in Fonda, this is the only known photo of FJ&G engine #5. Originally built for the Union Pacific Railroad, this ornate engine was supposedly purchased by the FJ&G after the UP refused the engine due to discrepancies concerning total weight. Fred Dansen was the engineer and D. Haines was the fireman. On the ground, from left to right, are trainmen George Robbinson, Jack Green, Harry Vandria, and W. Vaughn.

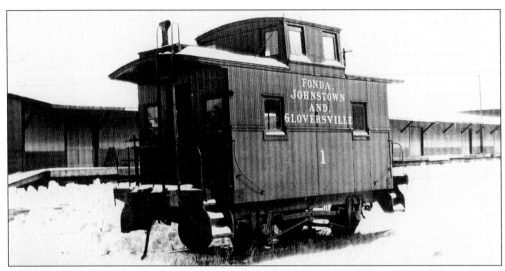

Above: FOUR WHEEL BOBBER #1. This was undoubtedly one of the cutest pieces of equipment owned by the railroad.
Left: THE KINGSBORO STATION. The station was built in 1875 along with depots at Mayfield, Cranberry Creek, and Northville to serve the Gloversville and Northville Railroad. The structure was torn down in 1958.
Below: THE PLATE GIRDER STEEL BRIDGE. This bridge was erected in 1897 to replace the aging wooden span over Cranberry Creek, just south of the station.

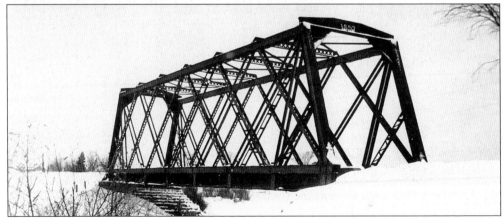

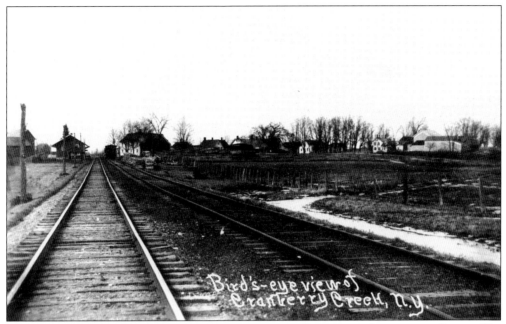

A View Facing North, just after Crossing the Bridge at Cranberry Creek. The station at Cranberry Creek is on the left and the boxcars are on a siding to the right of the mainline.

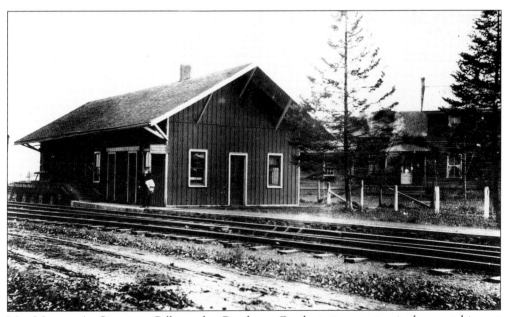

Mr. Myron A. Gilbert. Gilbert, the Cranberry Creek station master, is shown at his post near the turn of the century.

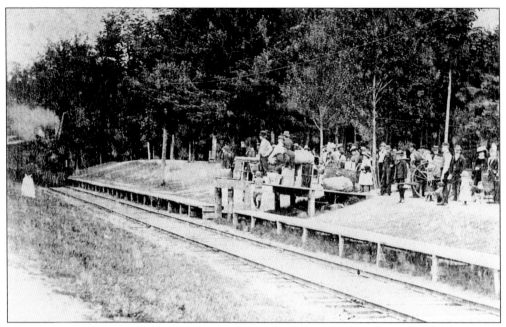

WAITING FOR A TRAIN. Before the first passenger station was built at Sacandaga Park, patrons waited near this freight platform to board the train.

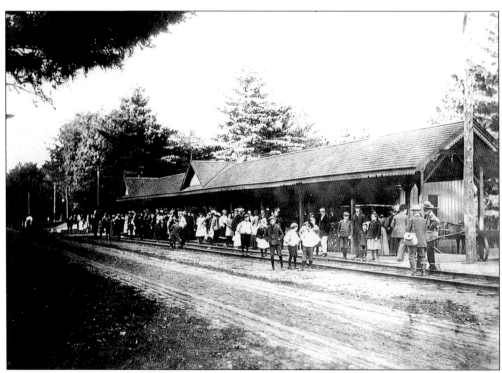

AN EARLY PHOTO OF PASSENGERS WAITING FOR THE TRAIN IN FRONT OF THE FIRST STATION AT SACANDAGA PARK.

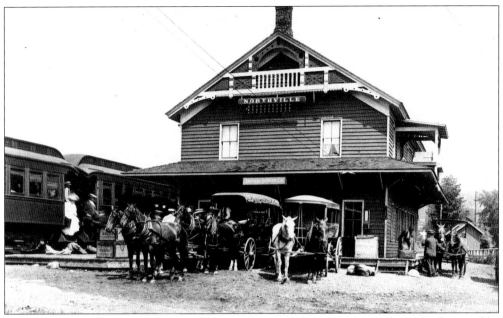

NORTHVILLE STATION AROUND THE TURN OF THE CENTURY. A horse-drawn hack owned by Mr. Lawton of Northville is parked next to the "Tally Ho Stage" and waits to take passengers across the bridge into Northville. The stage would often carry passengers on to Wells, Lake Pleasant, Pesico, and other points north.

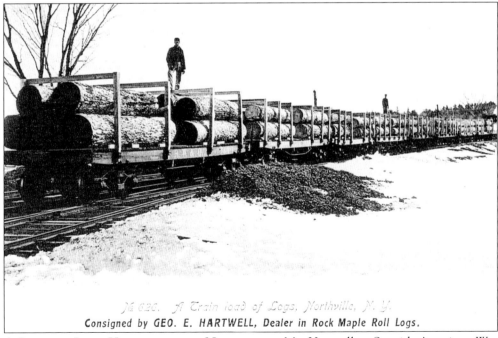

Consigned by *GEO. E. HARTWELL, Dealer in Rock Maple Roll Logs.*

A LOAD OF LOGS HEADED OUT OF NORTHVILLE. Mr. Hartwell, a Spanish-American War veteran and a prominent citizen of Northville, often purchased or consigned the best logs from the local lumbermen to gain top dollar prices from the highest bidding veneer mill.

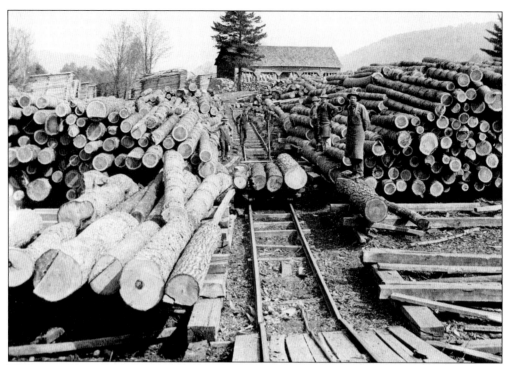

WORKMEN LOADING LOGS ON A SMALL TRAMWAY AT JOHN A. WILLARD'S SAWMILL, NEAR THE FREIGHT YARDS, IN NORTHVILLE.

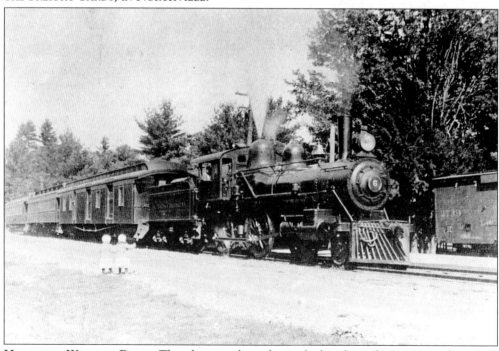

HEAR THE WHISTLE BLOW. The photographer who took this shot of #6 at Sacandaga Park seems to have picked two very brave little girls to pose while the engineer blew the loud steam whistle.

26

Book House
of
Stuyvesant Plaza

Locally Owned.
Truly Independent.
One of a Kind.

Knowledge

Passion

Character

Personality

Community

ANOTHER BOOK HOUSE

Market Block

BOOKS

Troy, NY

489-4761 *Albany, NY* **bhny.com**

Book Notes

s e n s e™
Independent Bookstores
for Independent Minds

Your locally-owned,
independent bookseller since 1975.
Books, children's books and maps.

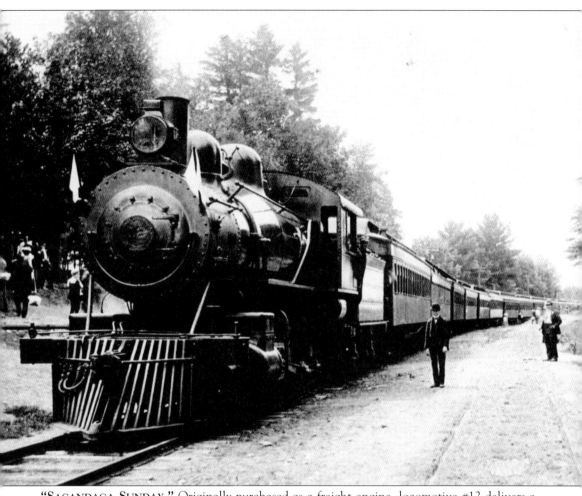

"SACANDAGA SUNDAY." Originally purchased as a freight engine, locomotive #12 delivers a 13-car "Sunday Excursion Train" to Sacandaga Park at the turn of the century.

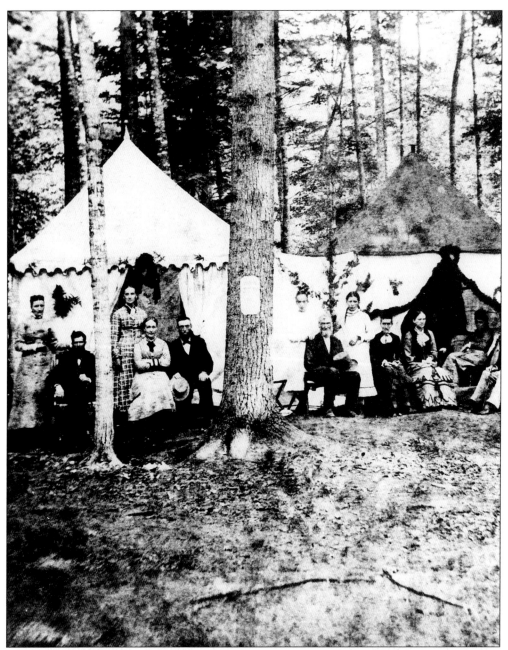

A Religious Encampment at "The Circle," across the River and just South of Northville, in the 1870s. Originally begun by the Methodists, this area was a popular wilderness meeting grounds for revivals and Bible studies long before the railroad was built. When the railroad arrived it quickly realized the area's potential and subsequently purchased most of the land on the west side of the river. The "Adirondack Conferences" circle in the woods soon gave way to wooden benches and a small pavilion, and the tents soon gave way to small cottages built around the circle. As the park grew to massive proportions, ultimately encompassing the meeting grounds, the religious groups decided that a quieter meeting place was needed, and made their new home in Round Lake, New York.

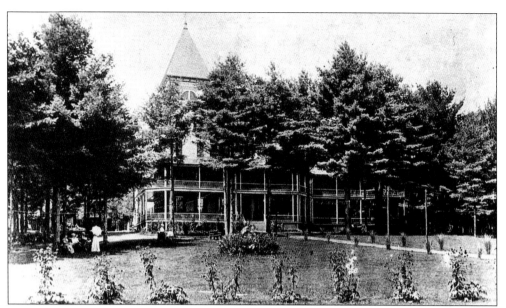

THE ADIRONDACK INN. The inn was one of the southern Adirondack's largest hotels, boasting many of the finest luxuries available to the patrons of the park each summer. Along with billiards and various gaming tables, the inn housed a four-lane bowling alley. Notice the sign stating "Gambling and Profanity Strictly Forbidden."

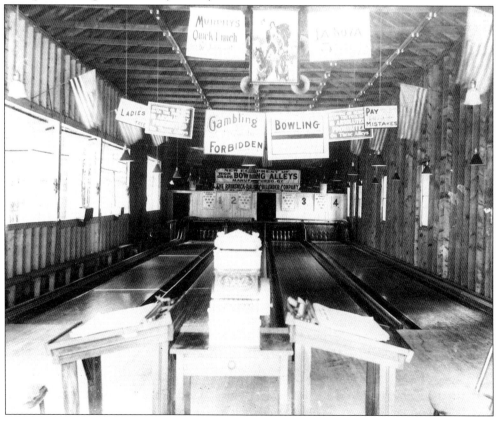

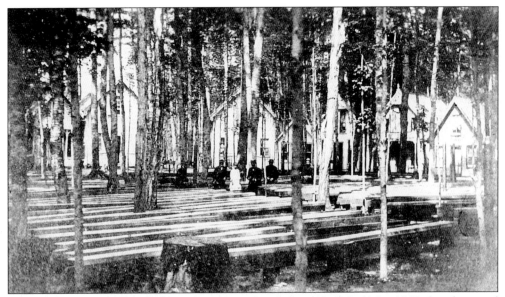

COTTAGES ON THE CIRCLE. This photo was taken before the fire of May 1898 that destroyed more than 100 cottages throughout the park.

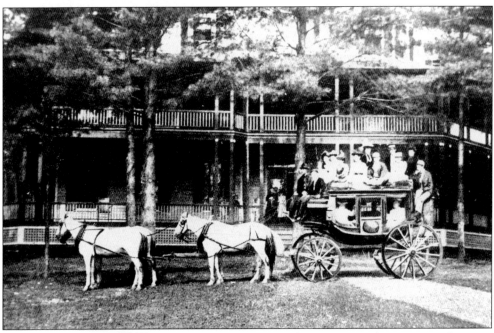

THE "TALLY HO" STAGE POSING FOR A PORTRAIT IN FRONT OF THE ADIRONDACK INN.

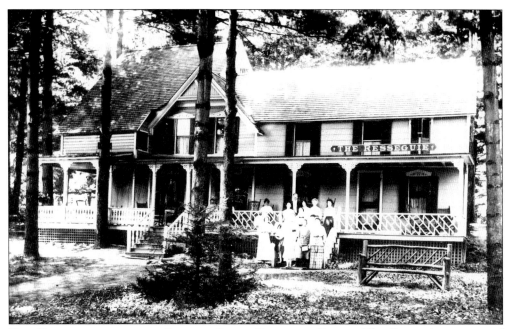

THE RESSEGUIE, WITH THE SUMMER STAFF POSING IN FRONT. The Resseguie was one of several picturesque hotels built within the park to serve the large summer crowds that visited each year.

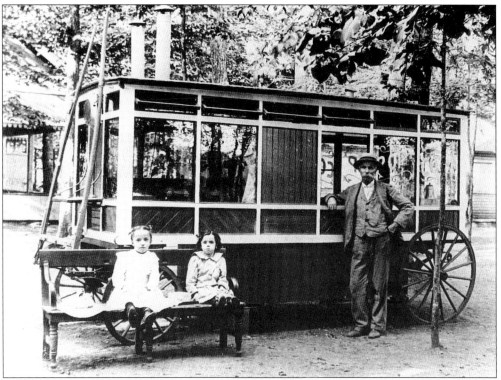

MR. MYRON LINDSAY FROM NORTHVILLE, NEXT TO A MOBILE CONCESSION STAND FOR POPCORN AT SACANDAGA PARK.

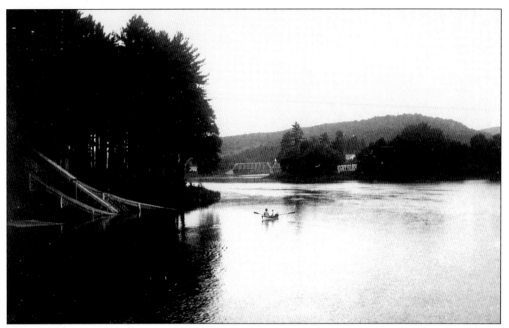

A Couple Enjoying a Romantic Boat Ride on the Sacandaga River. This photo, taken from the Sport Island Bridge, shows the toboggan slides near the shore and the Northville Bridge in the background.

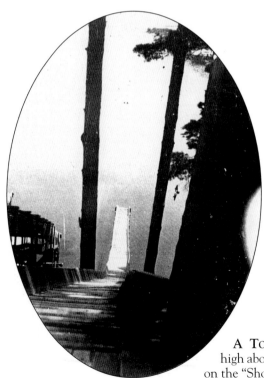

A Tobogganer's View. This image was taken high above the river, just before the point of no return on the "Shoot the Chutes" at Sacandaga Park.

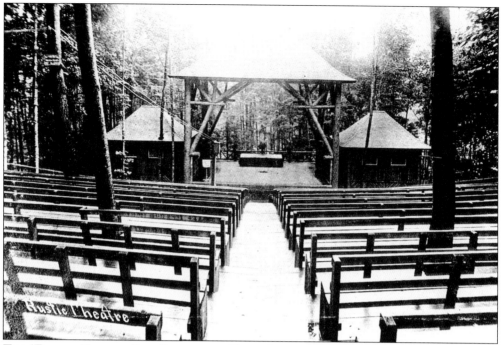

THE "RUSTIC THEATER" AT SACANDAGA PARK. Patrons were entertained under the pines by some of the best vaudeville and Broadway talents of the time.

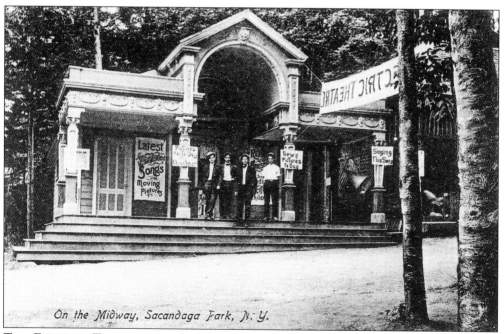

THE ELECTRIC THEATER. Another attraction along the midway at Sacandaga Park, the Electric Theater was introduced with the advent of electricity. This early movie house played the silent films of the era.

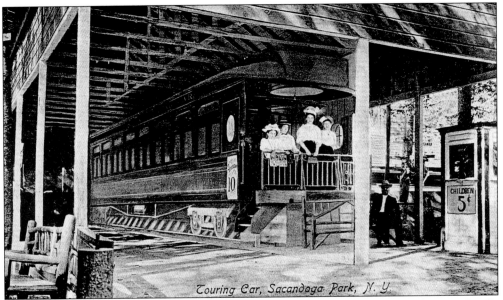

Touring Car, Sacandaga Park, N. Y.

"HALES TOURING CAR" AT SACANDAGA PARK. For 10¢, while listening to the sounds of a steam train played through a phonograph, ticket holders were treated to a scenic view from a panoramic backdrop attached to one side of the car on large revolving rolls. As the scenery rolled by the car was rocked from side to side by an electric motor attached to offset weights. Purchased in 1907 for $1,350, this railroad coach seems like an odd amusement ride considering this was the heyday of steam travel.

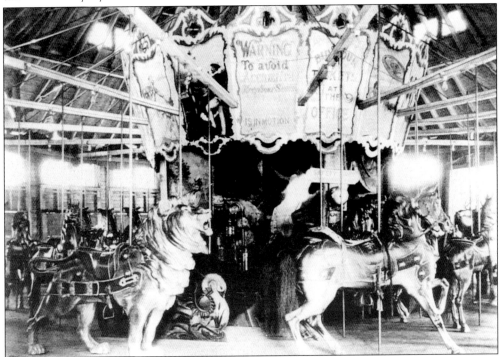

THE INTERIOR OF THE STEAM-POWERED CAROUSEL AT SACANDAGA PARK. Fortunately, this very unique ride was salvaged and currently resides at the Shelburne museum in Vermont.

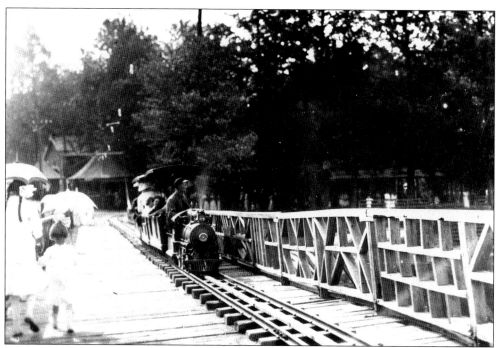

THE "SACANDAGA LIMITED." The Limited is shown here crossing the bridge at the end of the midway and heading toward Sport Island.

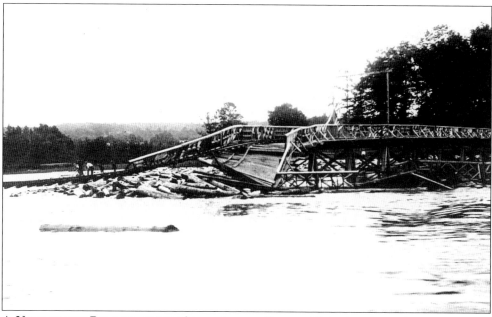

A VIEW OF THE REMAINS OF THE SPORT ISLAND BRIDGE. This view shows the narrow-gauge rails and ties of the miniature train dangling over the Sacandaga River after a late spring log run went through.

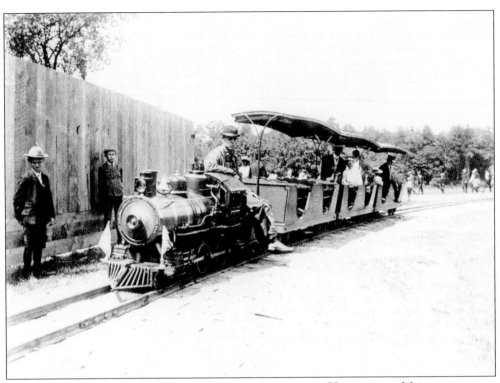

ANOTHER VIEW OF THE MINIATURE TRAIN RIDE AT SACANDAGA PARK. This photograph was taken on Sport Island next to the fence at the baseball diamond and grandstands.

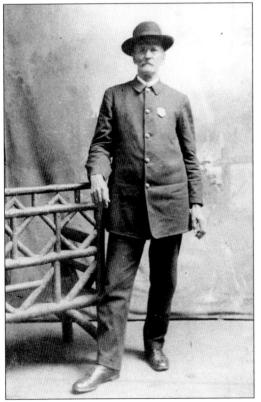

CONSTABLE SAM COOK. Cook is shown here posing for his portrait at one of the photo galleries in the park. Mr. Cook, along with other deputies, was hired by the railroad each summer to ensure that the many sojourners to the park kept their entertainment within legal limits.

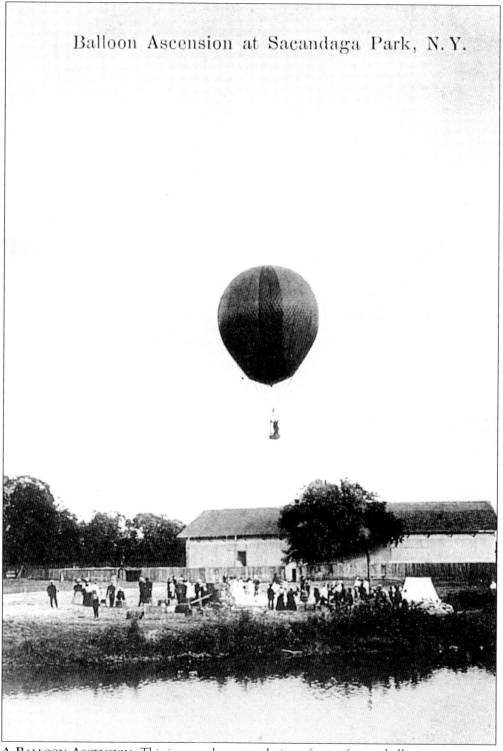

Balloon Ascension at Sacandaga Park, N.Y.

A BALLOON ASCENSION. This is an early postcard view of one of many balloon ascensions at Sacandaga Park, which took place on Sport Island throughout the late 1800s and early 1900s.

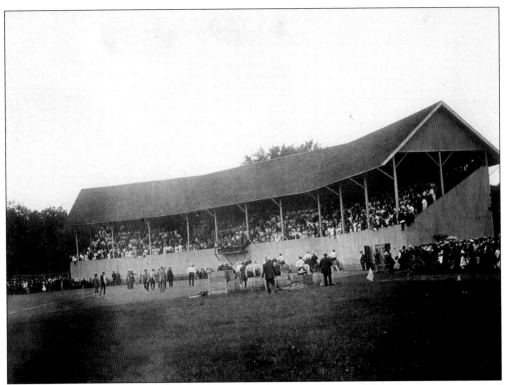

"THE GRANDSTANDS" ON SPORT ISLAND AT SACANDAGA PARK, 1906. This structure burned to the ground in 1919. The fire was believed to have been caused by coals from the miniature train that was housed below the bleachers at night. An attempt was made to rebuild the grandstands the following year, but the little engine and cars were never replaced.

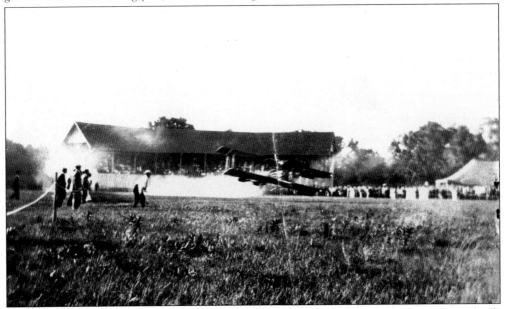

THRILLS IN THE AIR. With the grandstand in the background, an early flying machine thrills the crowds on the baseball field at Sport Island in the early 1900s.

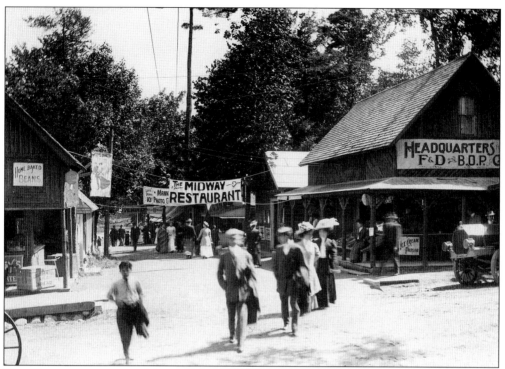

THE ENTRANCE TO THE MIDWAY AT THE PARK. To the right of the photo is a "Stanley Steamer" that often brought people from stops to the north. At the bottom of the midway in the far distance is the entrance to the Sport Island Bridge.

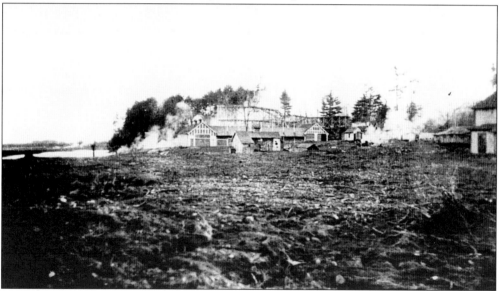

MAKING WAY FOR THE RESERVOIR. Like many communities and homes throughout the Sacandaga Valley that had to give way to the waters of the "Sacandaga Reservoir," properties below the taking line at the park were moved or burned before the arrival of the lake in 1930. With many buildings in the foreground already removed, this photo shows the roller coaster and parts of the midway being put to the torch.

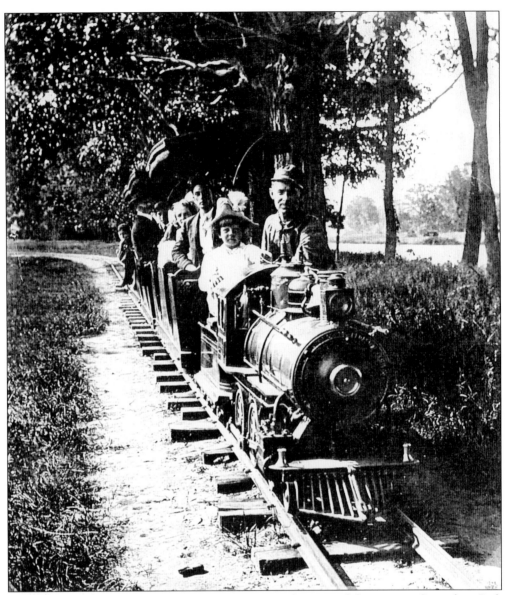

THE "SACANDAGA LIMITED." Engineer Dan Hunter lets one of the younger Sacandaga Park patrons blow the whistle on the park's miniature steam train. The little engine was purchased in 1901, and soon became a favorite with the employees and the summer excursionists.

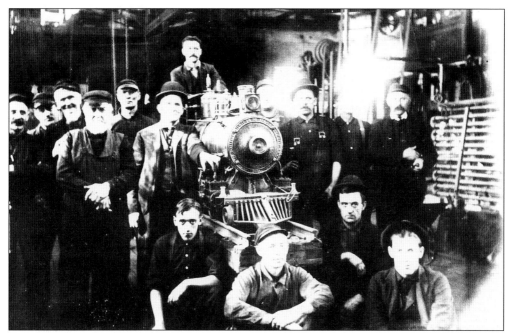

THE MINIATURE ENGINE FROM SACANDAGA PARK. A favorite among the workmen, the miniature engine spent its winters in the Gloversville shops. When time was available it was repaired and refitted for the upcoming summer season at the park. Engineer Dan Hunter, who often drove the little engine, is kneeling directly in front.

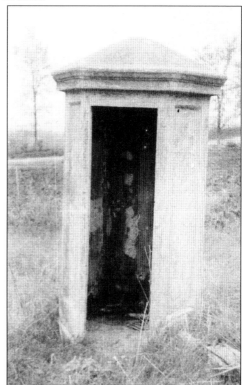

A TELEPHONE SHELTER. Undoubtedly the smallest structure on the railroad, this prefabricated concrete shelter was purchased at a cost of $78.80 in 1912 for the men assigned to the switch located at the Broadalbin junction, a few miles north of Gloversville.

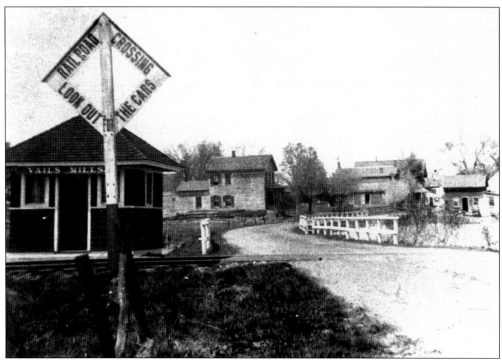

THE VAIL MILLS PASSENGER SHELTER. The passenger shelter on the Broadalbin line was rebuilt in 1907.

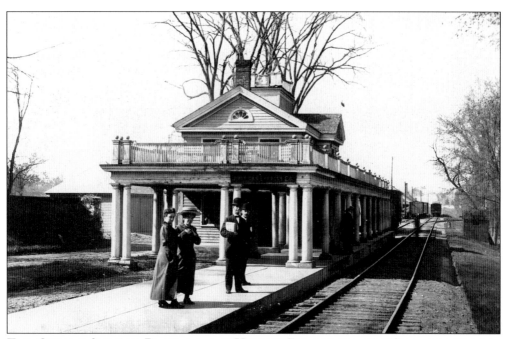

THE ORNATE STATION BUILT BY THE HUSTED FAMILY FOR THE GLOVERSVILLE AND BROADALBIN RAILROAD. This photo was taken from the stone bridge near Kenyetto Creek.

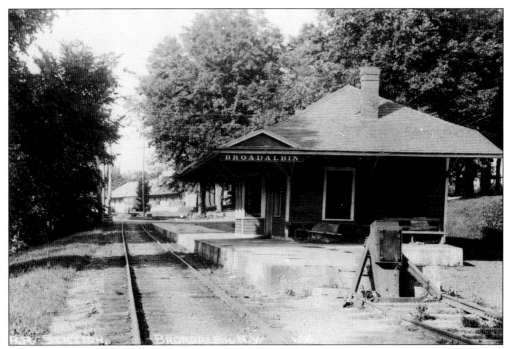

THE BROADALBIN STATION. A fire ravaged the original station, causing the colonnade to be removed, but the first floor was apparently salvaged. It remains intact and has housed many businesses over the years.

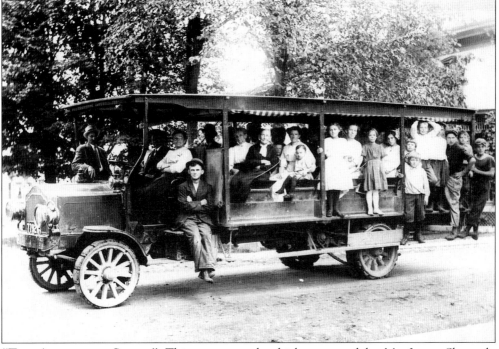

"THE AMSTERDAM STAGE." This gas-powered vehicle, operated by Mr. James Shattuck, connected passengers from Broadalbin with Amsterdam for many years in the early 1900s.

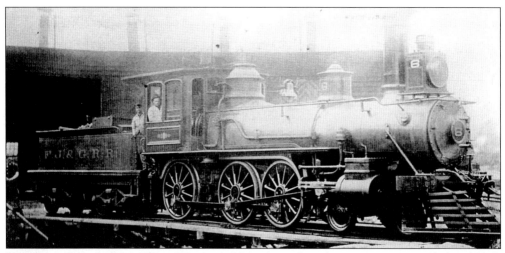

THE FIRST ENGINE #6, A "TEN WHEELER." It is shown here being spun on an early hand-built turntable in Gloversville. This ornate engine was believed to have been sold to the Saranac and Lake Placid as their No. ! in 1893.

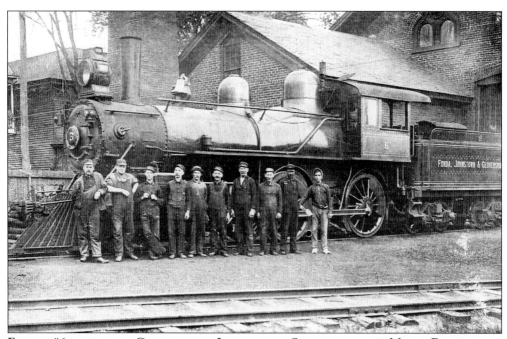

ENGINE #6 BEHIND THE GLOVERSVILLE LOCOMOTIVE SHOP AFTER SOME MINOR REPAIRS AND PAINTING IN 1900. Several of the men posing here have been identified, including Andrew Stoutner (second from the left), Dan Hunter (third from the left), and Fred Richey (fourth from the left).

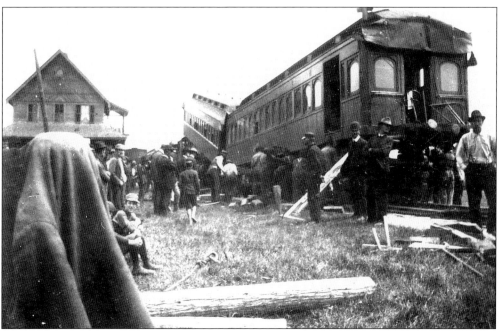

SUNDAY TRAFFIC. Traffic was especially heavy on Sundays during the summer; often several trains would travel to Northville and return to keep up with the day-trippers headed to Sacandaga Park. This wreck at the Mayfield station on Sunday, August 22, 1903, involved two trains returning from the park. A train, with two coaches, had stopped in Mayfield carrying a young woman and her child; #6, approaching the station, rounded the corner and could not stop in time to avoid the accident. The woman and her child were inside the coach as #6 drove up the aisle, but escaped, miraculously unharmed.

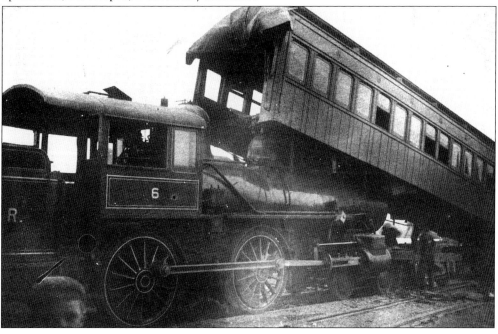

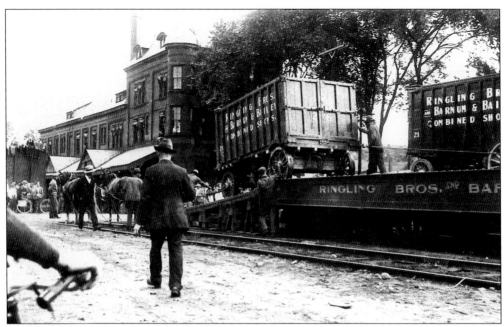

THE RINGLING BROTHERS AND BARNUM AND BAILY CIRCUS UNLOADING CIRCUS WAGONS IN GLOVERSVILLE IN THE 1920s. This was always a big event and almost as much fun to watch as the shows themselves.

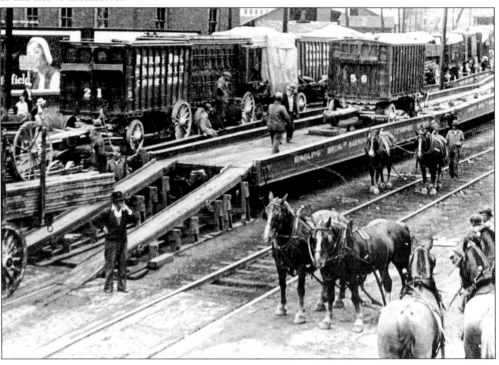

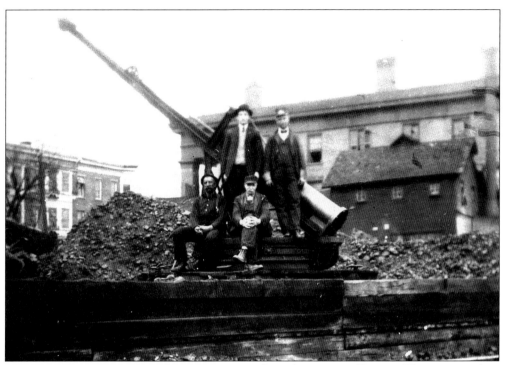

WORKMEN IN FRONT OF THE STEAM-POWERED COAL LOADER IN FONDA. The man standing on the right appears to be an engineer. The Hotel Roy is in the background.

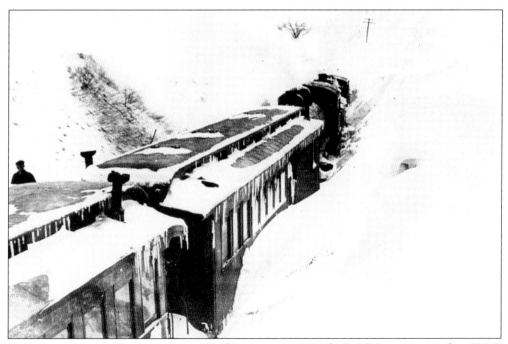

SNOWBOUND NEAR SAMMONSVILLE. Drifting snow on March 7, 1920, covers another FJ&G passenger train on its way north from Fonda.

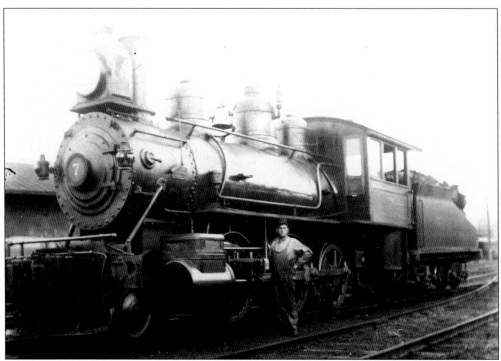

ENGINE #7. Unlike her sister engine (#10), engine #7 is photographed sporting a pony truck installed at the Gloversville shops.

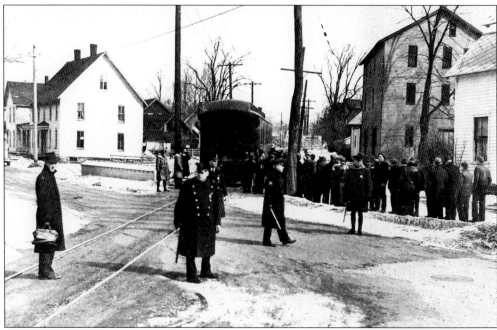

VOTING AT THE CORNER OF NORTH AND ARLINGTON STREETS, GLOVERSVILLE, EARLY 1930s. Local leather workers are shown here voting on a new contract in a baggage combine supplied by the railroad. The workers fought hard for fair wages from the wealthy and very powerful tannery owners of the time. Chief of Police Lewis Fish (center front) can be seen here.

48

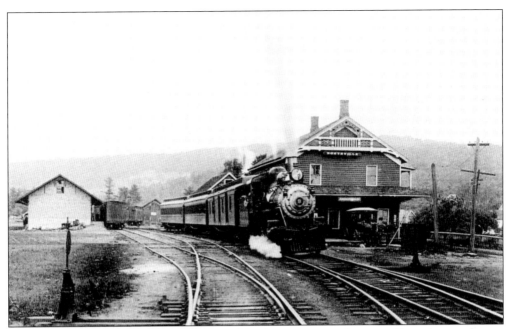

ENGINE #8, HEADED FOR POINTS SOUTH. After being spun on the turntable and recoupling to the baggage car, #8 makes ready to leave Northville with a passenger train.

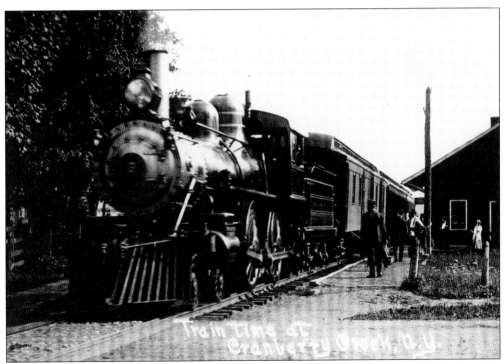

AN EARLY 1900S POSTCARD. This image speaks for itself. The entire area is now under the waters of the Sacandaga Reservoir.

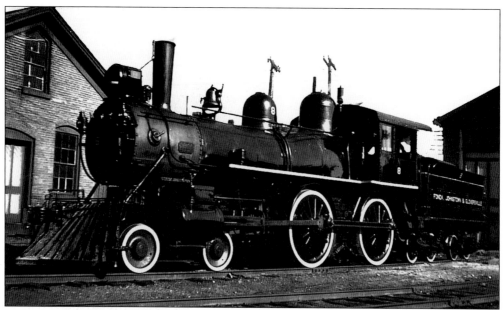

ENGINE #8, FRESHLY PAINTED AND REPAIRED, EMERGING FROM THE LOCOMOTIVE SHOPS.

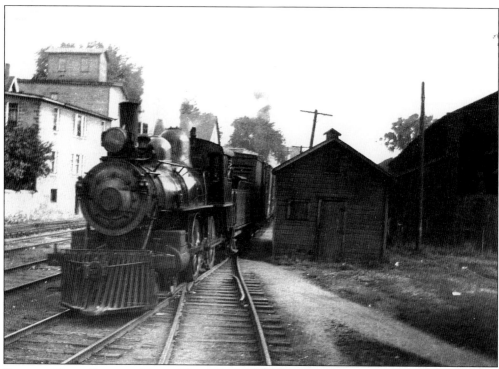

ENGINE #8 ON FREIGHT DUTY. This photograph was taken next to the small coal shed on Spring Street directly behind the station in Gloversville.

ENGINE #8 BUILDING A HEAD OF STEAM
IN THE 1930S AT THE LOCOMOTIVE SHOP
ON FULTON STREET, GLOVERSVILLE.

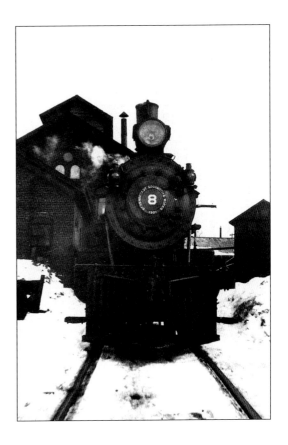

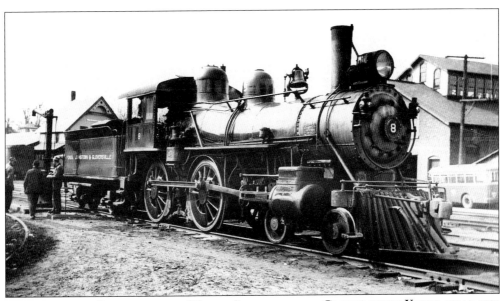

ENGINE #8 AND CREW NEAR THE WATER COLUMN IN THE GLOVERSVILLE YARDS, NEAR THE
FULTON STREET CROSSING.

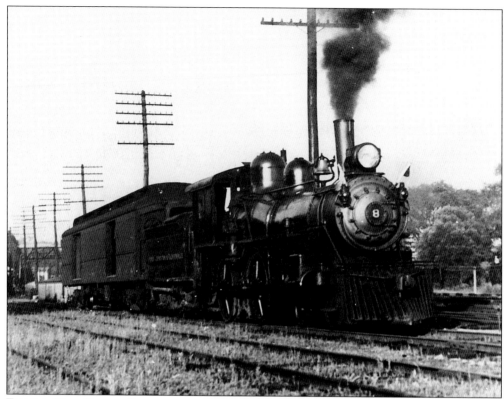

ENGINE #8 IN FONDA SPORTING THE WHITE FLAGS OF AN "EXTRA" AND PULLING A NYC
CENTRAL BAGGAGE CAR.

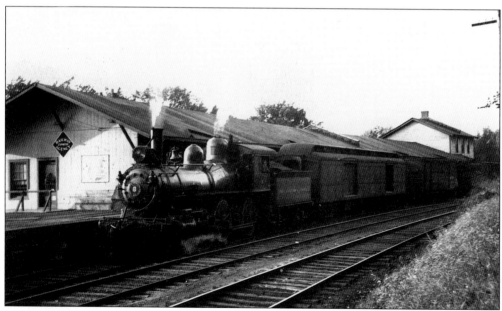

ENGINE #8 CONDUCTING BUSINESS AT THE FREIGHT OFFICE IN JOHNSTOWN IN THE 1930S.

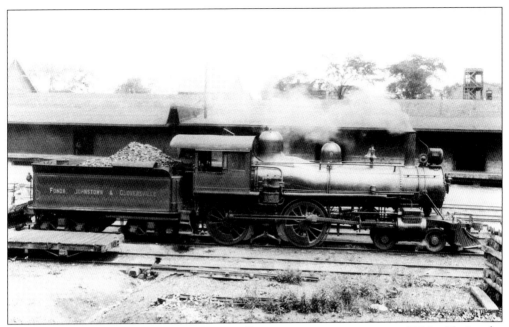

ENGINE #8 BEHIND THE FREIGHT HOUSE IN GLOVERSVILLE IN THE EARLY 1920s. Notice the fire training tower in the background, located on Cayadutta Street.

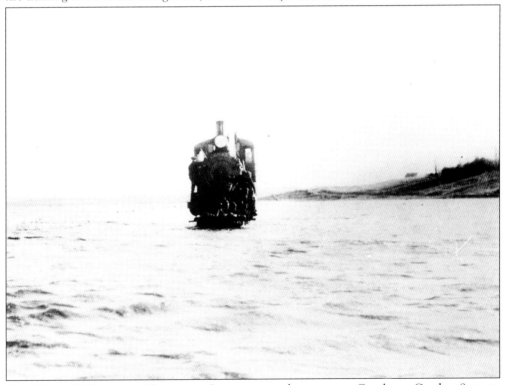

THE FJ & G WORKING MIRACLES. Carrying a work crew near Cranberry Creek, #8 seems almost divine as it rides on rails hidden just under the rising waters of the newly constructed "Sacandaga Reservoir."

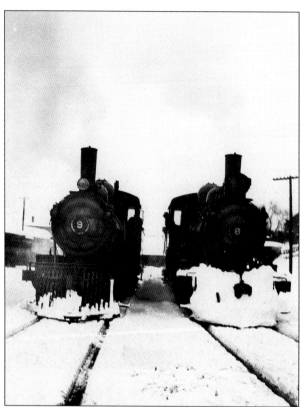

ENGINES #8 AND #9. Here, the engines have stopped for a moment while the engineers discuss the day's work orders, creating the perfect opportunity for a local rail fan Ira Barnes to snap this great shot.

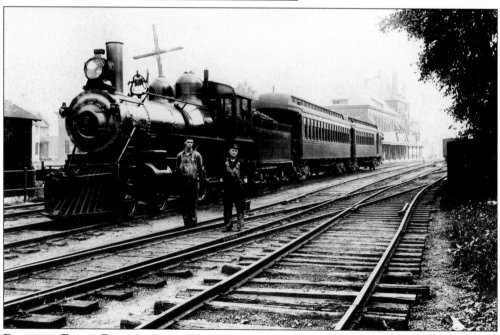

ENGINEER FRANK ROBINSON AND FIREMAN LESLIE COLLINS. The two posed in front of #9 at the Gloversville station before steaming north out of the city. The engine was still sporting an older oil lamp.

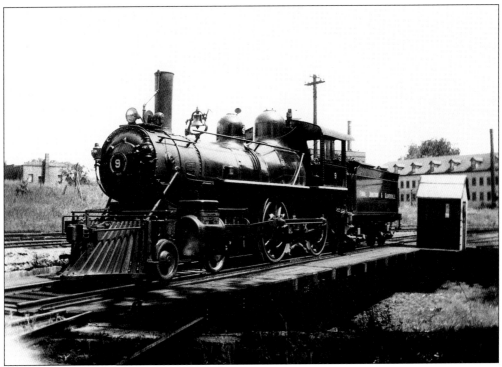

ENGINE #9 ON THE TURNTABLE IN GLOVERSVILLE, 1930S.

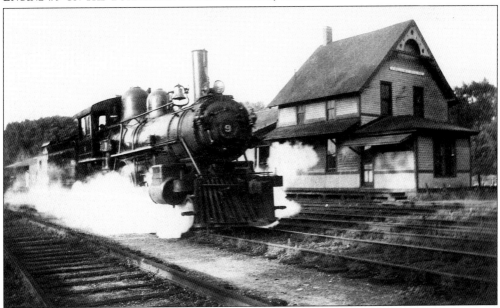

LETTING OFF STEAM NEXT TO THE FREIGHT OFFICES ON FULTON STREET. Engine #9, as well as the second #6 and #8, was built by the Schenectady Locomotive Works around the turn of the century. These engines were American-type engines with a 4-4-0 wheel arrangement and looked similar in appearance. An easy way to tell them apart at a glance is the headlamps; #9 had an oddly small electric headlamp; #8 a larger electric type; and #6 carried an oil-fired headlamp.

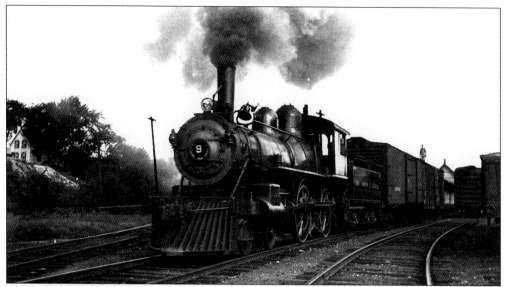

NUMBER 9 COUPLING FREIGHT CARS IN JOHNSTOWN, 1934.

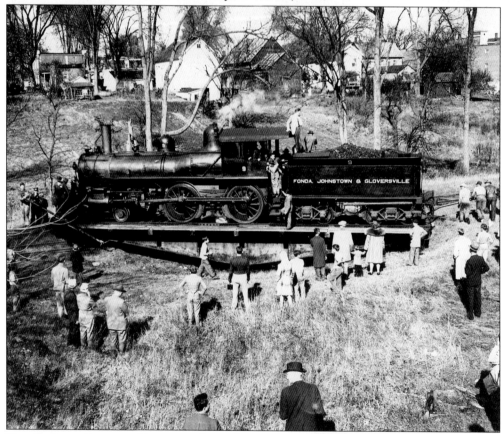

THE CAPITAL DISTRICT RAILROAD CLUB. It was a beautiful fall day in October of 1946 when the Capital District Railroad Club reached their destination at Broadalbin. Rail fans of all ages watch as #9 is pushed by hand on the turntable for the return run to Fonda.

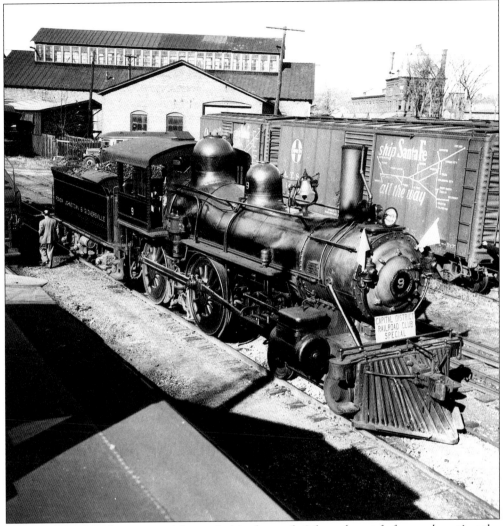

ENGINE #9. An enthusiastic rail fan took this photo of #9 from the roof of snowplow #1 at the Gloversville yards in October 1946. The station is visible in the background.

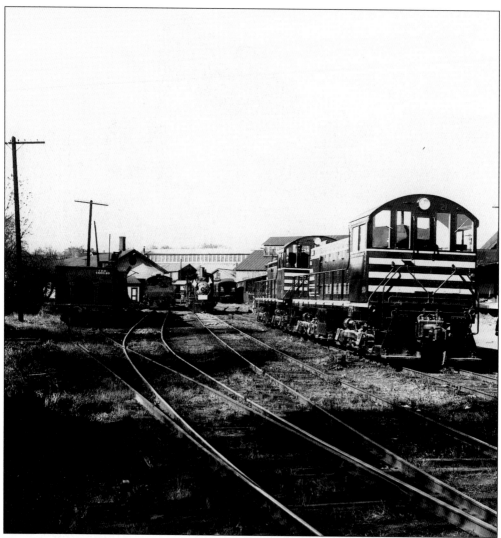

THE FUTURE IS WAITING. Alco diesels #20 and #21 momentarily divert the attentions of rail fans during a 1946 excursion trip from Fonda to Broadalbin, while #9 waits in the distance for the ride to continue.

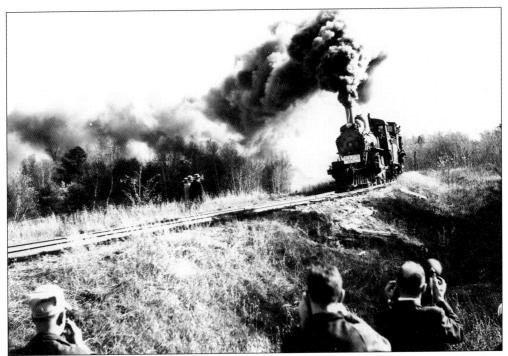

NUMBER 9 STEAMING AROUND THE BEND. This photo was taken on the Broadalbin line during the 1946 rail fan trip sponsored by the Capital District R.R. Club. The photographer to the lower left is railroad historian David Nestle, author of *The Steam and Trolley Days*, a previous history of the FJ&G.

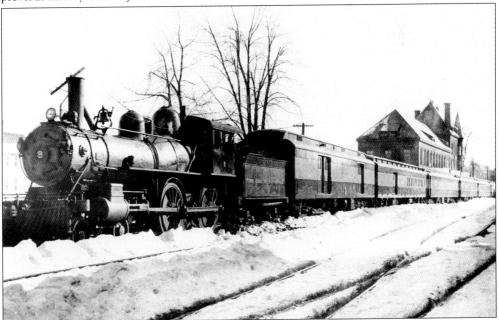

THE FREEDOM TRAIN VISITS GLOVERSVILLE. Before being scrapped in 1950, engine #9 was given the honor of supplying steam heating for the NYS "Freedom Train" exhibit. Sadly, this event in February 1949 marked the last head of steam the engine would produce.

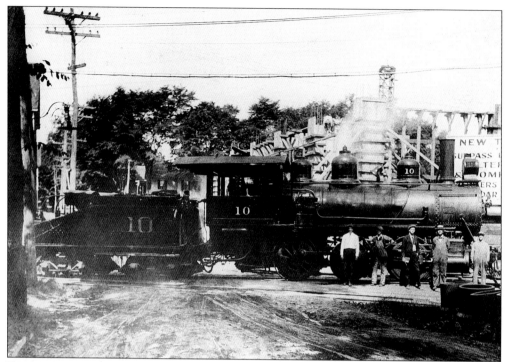

ENGINE #10. Here, the engine poses for a shot in front of the new Surpass Leather Tanneries construction site in 1920, on Lincoln Street in Gloversville.

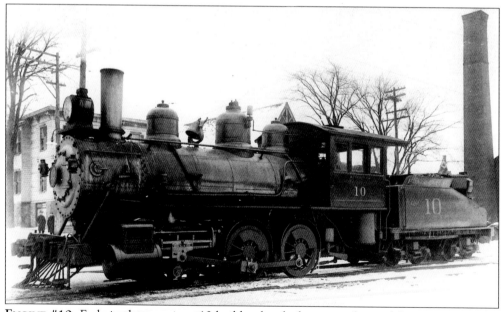

ENGINE #10. Early in the morning #10 builds a head of steam in front of the entrance to the locomotive shops in Gloversville.

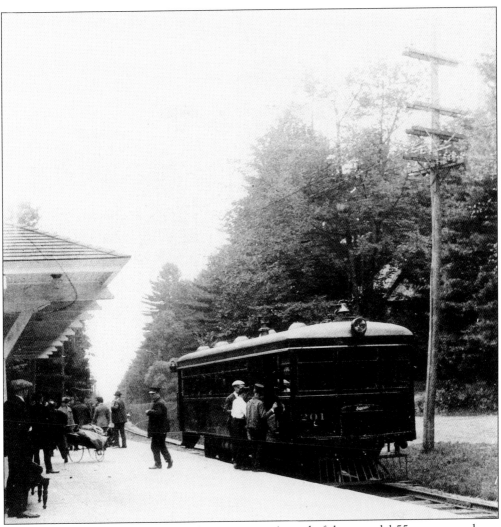

THE RAILROAD'S ANSWER TO THE AUTOMOBILE. A total of three model 55 gas-powered cars were purchased from the J.G. Brill Co. between 1922 and 1923 to cut costs while continuing quality high-speed service. Taken at the Sacandaga station, this is one of the few photos showing #201.

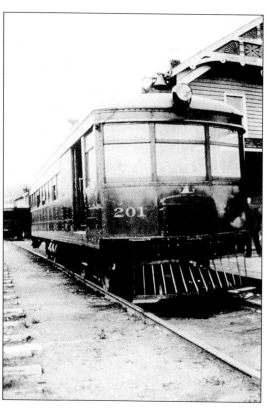

GAS CAR #201 AT THE NORTHVILLE STATION IN THE 1920s. One of the other two identical gas cars #200 or #202 is in the background, ready to head south.

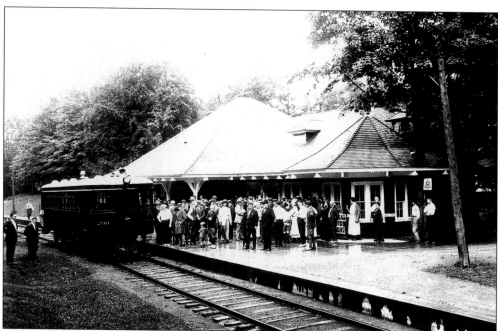

GAS CAR #200 AT THE NEW SACANDAGA STATION IN AUGUST 1922. The men wearing white derby hats are FJ&G stockholders who traveled to the park on the gas car for a meeting at the Adirondack Inn.

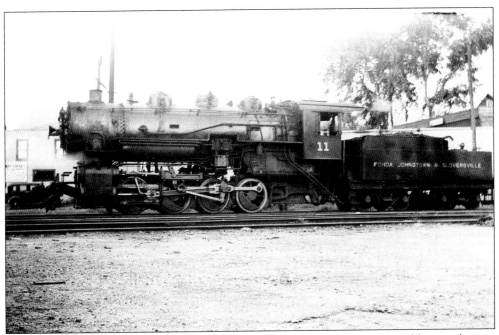

ENGINE #11. Facing north, #11 fills her tanks from the water tower (barely visible over the rear of the tender) in the Gloversville yards, *c.* 1930.

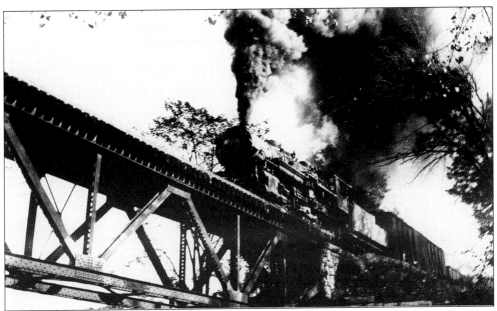

ENGINE #11. Here the engine is steaming up from Fonda, crossing the high trestle over the Cayadutta Creek at Berryville, between Sammonsville and Fonda, in the early 1930s.

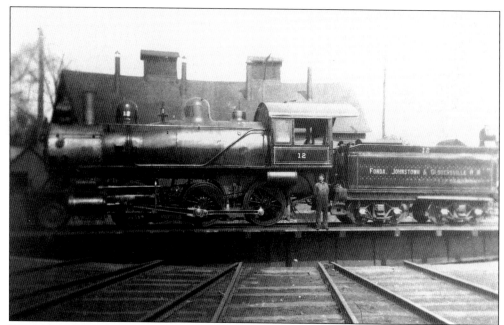

ENGINE #12 ON THE GLOVERSVILLE TURNTABLE. This engine was considered the most powerful locomotive on the railroad, possessing a boiler pressure of over 200 pounds and a weight of over 70 tons. When delivered on April 6, 1900, it obviated the practice of hauling short trains up the grade from Fonda.

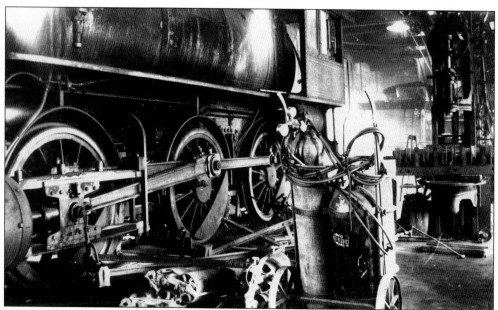

ENGINE #12. Here, the engine is being refitted at the locomotive shops in Gloversville.

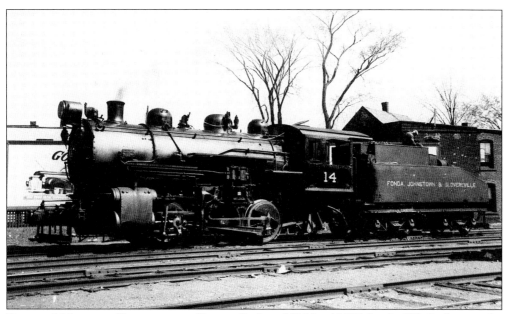

ENGINE #14 IN THE GLOVERSVILLE YARDS. Built in 1926 by ALCO for the FJ&G, this was the railroad's newest steam engine. It remained in service later than any of the other steamers, finally meeting with the scrapper's torch in 1955.

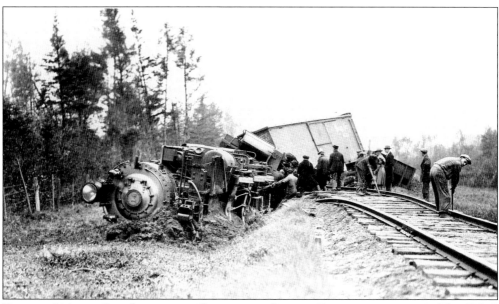

ENGINE #14 ON ITS SIDE NEAR CRANBERRY CREEK, OCTOBER 12, 1926. The FJ&G Northville Division used a lighter 65-pound rail during its construction. NYC Railroad engineers, who sold #14 to the FJ&G, warned the railroad that use of engines of this type, built without a lead (or pony) truck, would result in a derailment on this section.

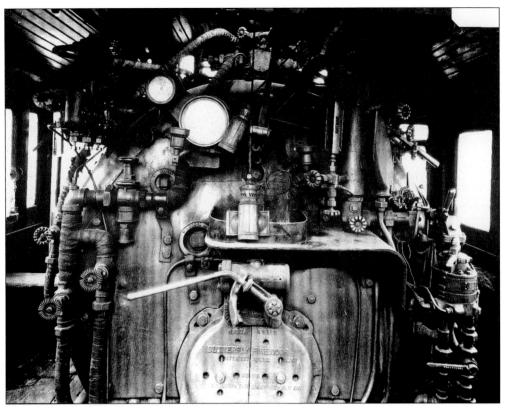

INSIDE THE CAB OF #14.

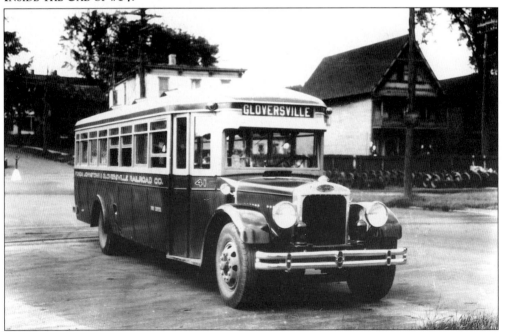

FJ&G RAILROAD MACK MOTORBUS 141, FACING SOUTH ON BROAD STREET ACROSS FROM THE LOCOMOTIVE SHOPS.

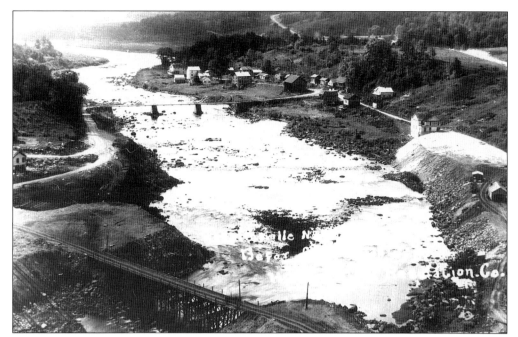

A Partial View of the Sacandaga River Valley and the Village of Conklingville. This photo was taken two years before completion of the Conklingville Dam, under construction in the foreground.

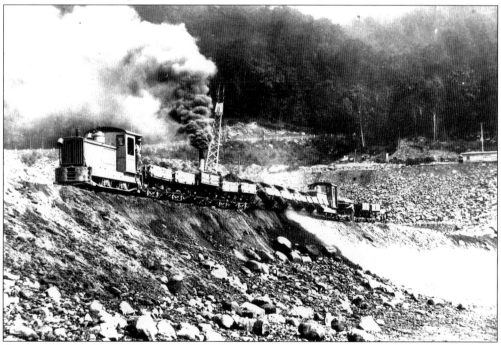

Construction Progressing on the Conklingville Dam Project. This photo shows two of the narrow-gauge Plymouth diesels, called "Dinkies," used to haul fill during dam construction in 1929 for the earthen dam project built to control the flow of the Sacandaga River.

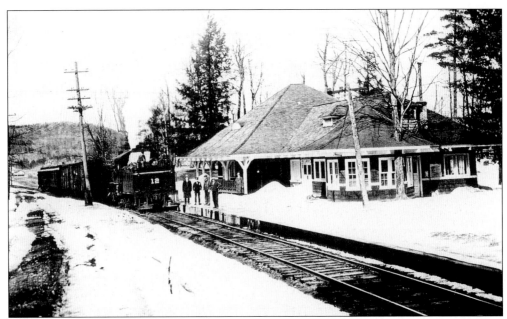

THE LAST TRAIN OUT ON THE NORTHVILLE DIVISION. With the Northville station visible in the background, Engine #12 pauses at the Sacandaga station for the last time on March 16, 1930.

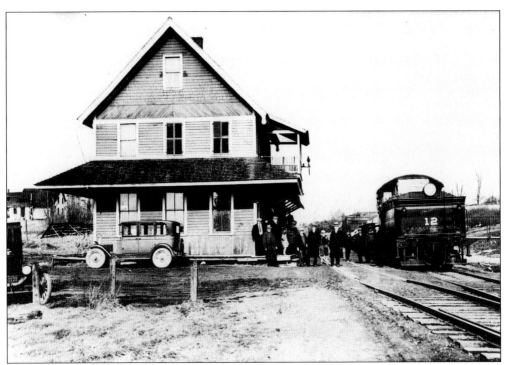

MARCH 16, 1930. This date marked the last train out on the Northville Division. Pulled by #12 and stopping at each depot along the way, this mixed train waits at the Mayfield station while employees say their farewells and usable equipment is loaded.

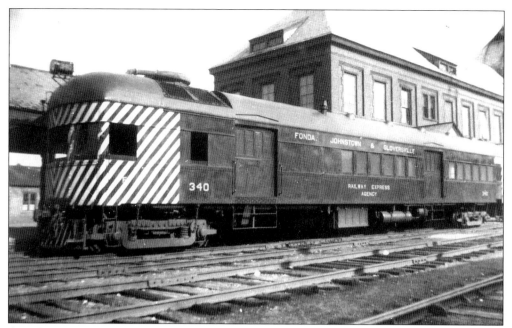

GAS CAR #340, STILL SPORTING ZEBRA STRIPES, AT THE GLOVERSVILLE STATION. The car was purchased in 1938 for express mail service on the Fonda Division.

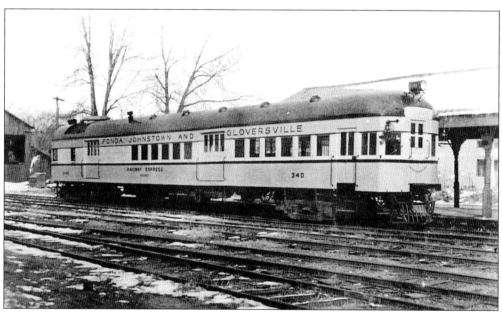

GAS CAR #340, PAINTED YELLOW, ORANGE, AND BLACK, AT THE GLOVERSVILLE STATION.

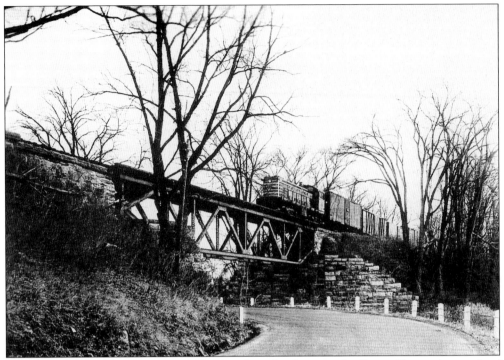

DIESEL ENGINE #21. The engine is hauling box freight over the Berryville trestle, north of Fonda, headed toward Johnstown.

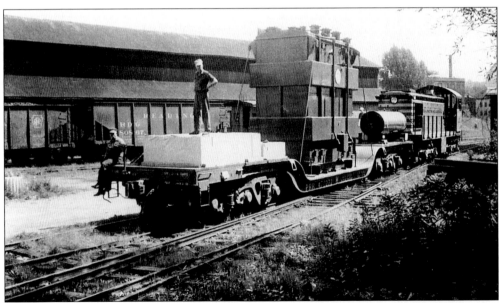

ENGINE #21 AT THE GLOVERSVILLE YARDS, DELIVERING A POWER TRANSFORMER FOR NIAGARA MOHAWK, SEPTEMBER 8, 1959.

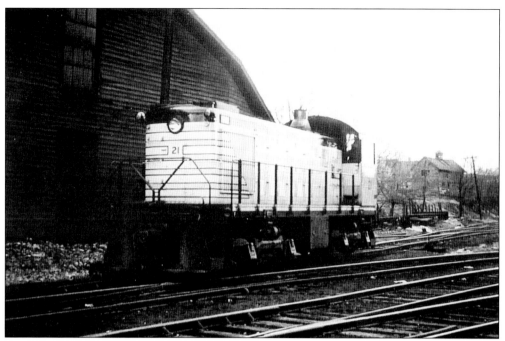

DIESEL #21 AT THE GLOVERSVILLE YARDS IN THE LATE 1950S.

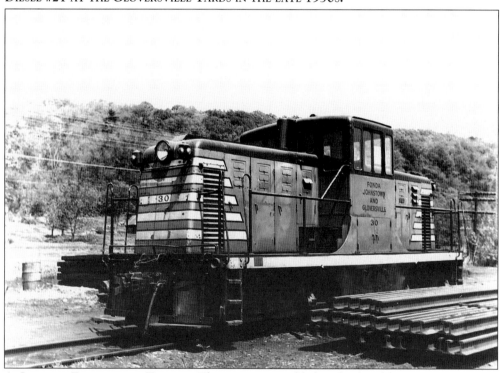

A GENERAL ELECTRIC 44-TONNER. This engine was added to the diesel roster as #30 in 1950. The small diesel was never a favorite of the work crews, and often had difficulties on the grade coming up from Fonda. Despite its shortcomings, the little center cab remained on the railroad until 1967. This aging diesel is still in service on the Burlington Junction Railway in Iowa!

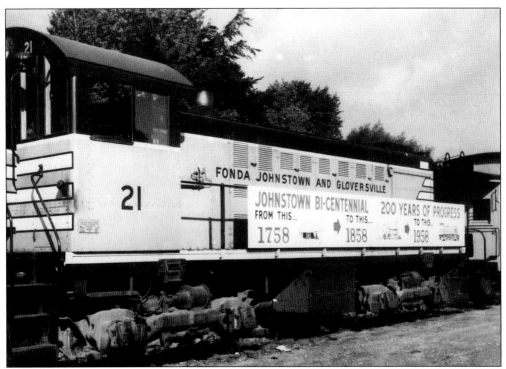

DIESEL #21. Alco diesel #21 with caboose #3 in tow displays a banner celebrating the city of Johnstown's 200th birthday in 1958.

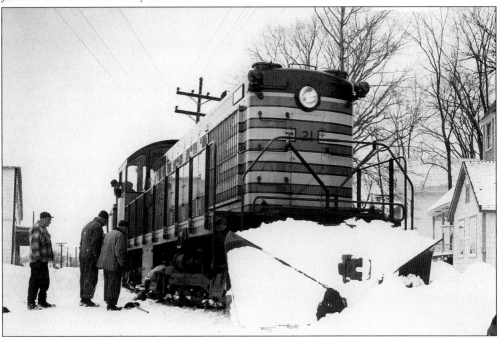

RERAILING. Engineer Pete Vosburg looks on as Percy Daniels, Pete Davis, and Cylon Fassett attempt to rerail the front truck of #21. Snow would often pack down on road crossings, causing derailments to engines and cars.

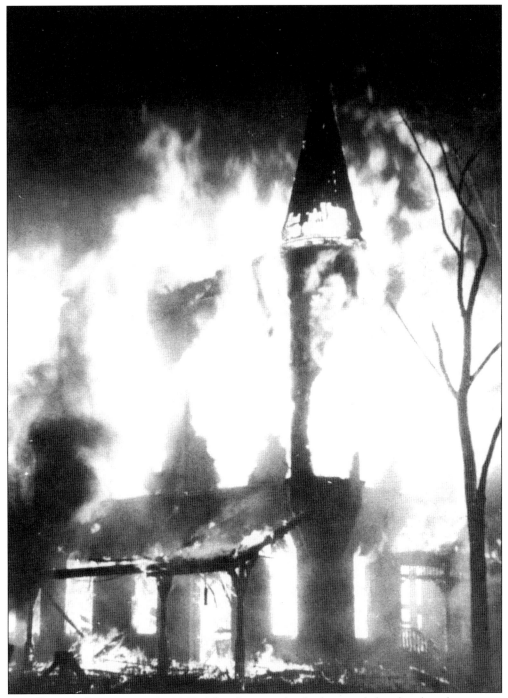

THE FIRE ON SEPTEMBER 19, 1969. This fire completely destroyed the abandoned passenger station in Gloversville. The area is now the site of the trailhead park, and an FJ&G boxcar has been placed here to be used as a railroad museum.

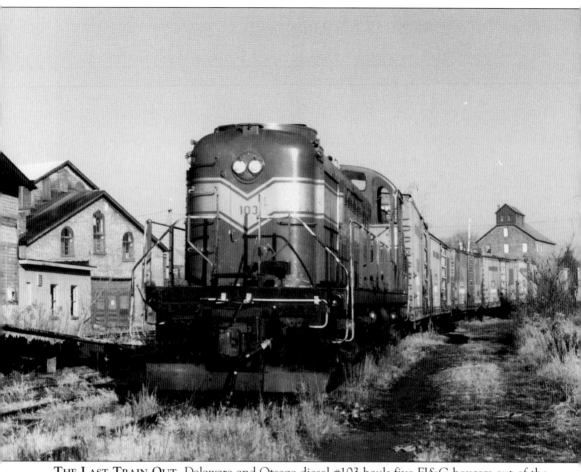

THE LAST TRAIN OUT. Delaware and Otsego diesel #103 hauls five FJ&G boxcars out of the Gloversville yards late in November of 1984. This marked the last official use of the railroad before its abandonment.

Two
The FJ&G Railroad's Electric Division

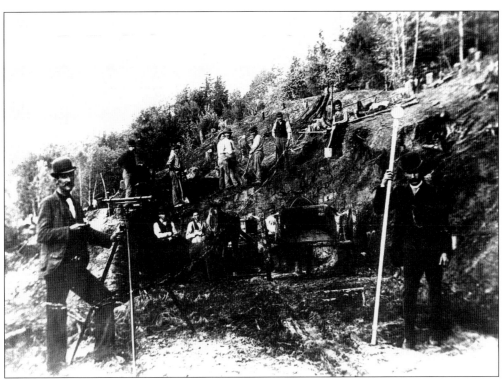

A CAYADUTTA ROAD CREW. The crew is filling horse-drawn wagons by hand during the line's construction in 1892, near Cayadutta Park, one mile north of Fonda. It was here, presumably soon after this photo was taken, that an accidental dynamite explosion killed a team of horses and their driver.

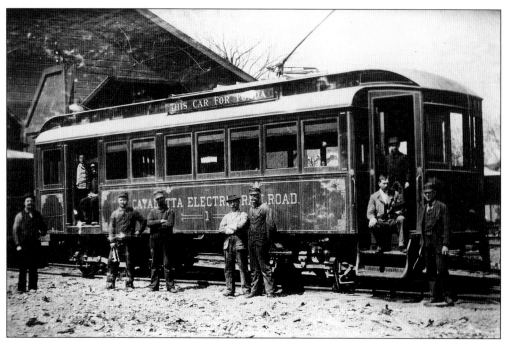

CAYADUTTA ELECTRIC #1 AT THE CAR BARN IN GLOVERSVILLE. The Cayadutta purchased four cars of this style from the Gilbert Co. in 1893.

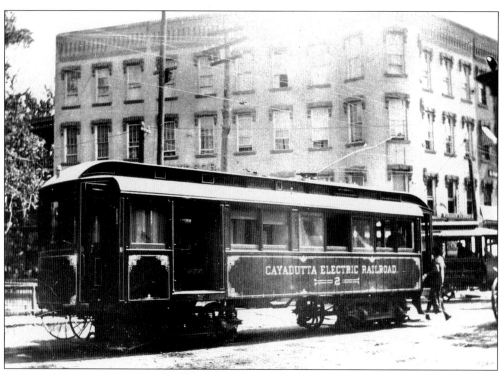

CAYADUTTA ELECTRIC CAR #2. The car is pictured at the intersection of Main and Fulton Streets in Gloversville in the late 1890s.

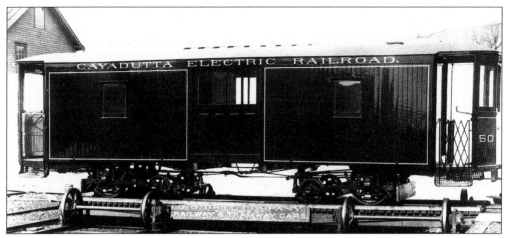

BAGGAGE CAR #50. This is a Brill Company builder's photo of baggage car #50 before the car was shipped to the Cayadutta Electric Railroad, *c.* 1893.

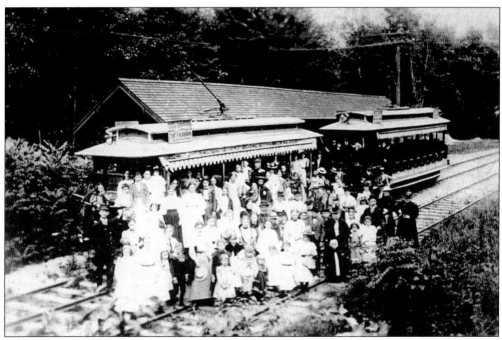

PICNICKERS POSING FOR A PHOTO IN FRONT OF THE CAYADUTTA PARK STATION, NORTH OF FONDA.

"A Sunday Picnic Party" at Cayadutta Park, just North of Fonda. This small park was originally built by the Cayadutta Electric Railroad in 1893 to compete with their rival, the FJ&G, and the popular park at Sacandaga.

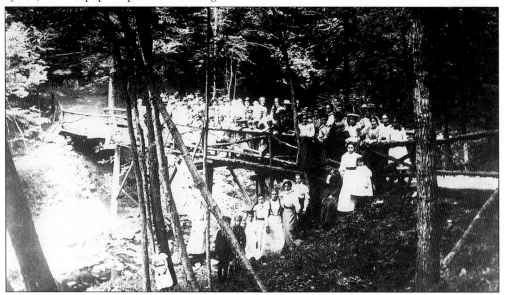

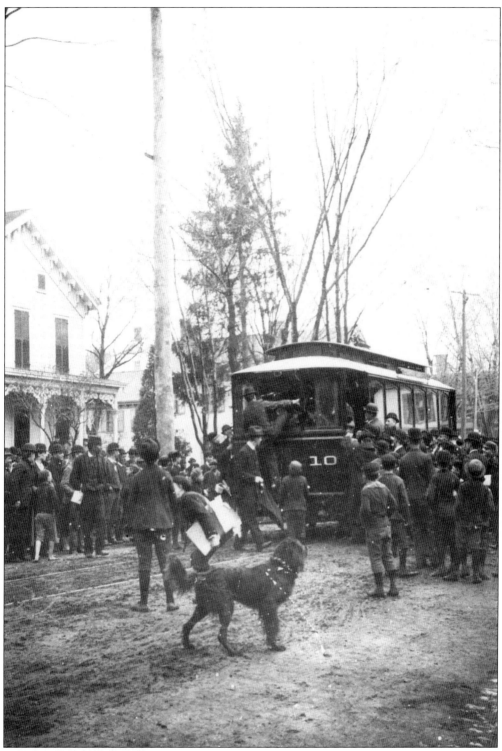

An Early Electric Car. This photograph is identified as "The first electric car in Johnstown," dating the picture to sometime in May of 1893.

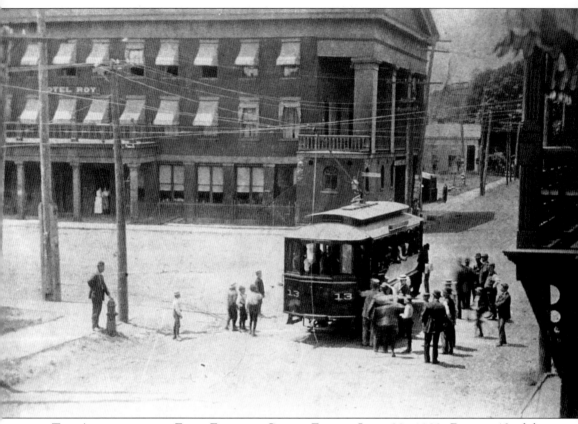

THE ARRIVAL OF THE FIRST ELECTRIC CAR IN FONDA, JUNE 29, 1893. Engine #13 of the Cayadutta Electric Railroad is shown here drawing a crowd of curious onlookers on Main Street during this historic event.

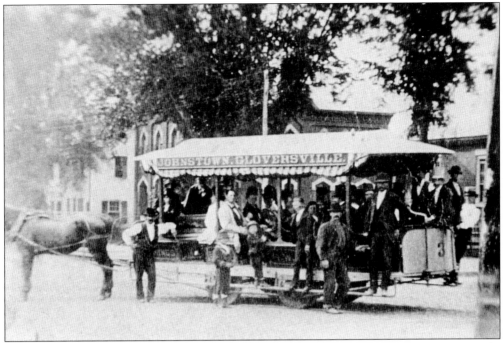

JOHNSTOWN, GLOVERSVILLE AND KINGSBORO HORSE RAILROAD CAR #3 IN THE 1880s. At the time this was considered the latest thing in transportation and, for a time, it ran in successful competition with the FJ&G.

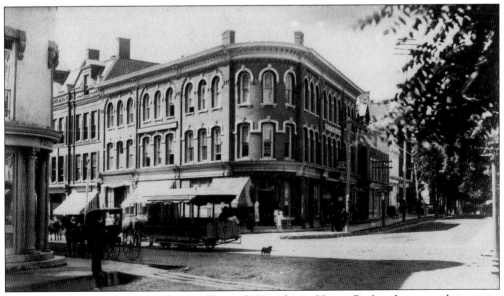

CAR #5. The Johnstown, Gloversville and Kingsboro Horse Railroad operated in quiet competition with the FJ&G for several years. Car #5 is shown here heading south on Main Street at the intersection of Fulton Street in Gloversville.

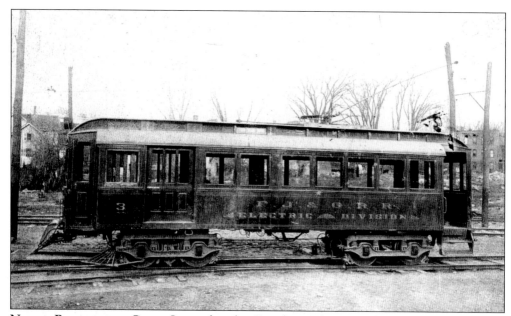

NEWLY RE-LETTERED CARS. Soon after the Cayadutta Electric and the FJ&G merged, the Cayadutta cars were re-lettered as the "FJ& GRR Electric Division."

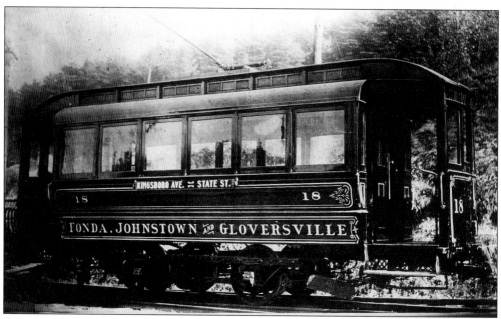

ONE OF THE EARLY FOUR-WHEELED "BOBBER" CARS. These ornately painted cars served the Gloversville belt line for many years.

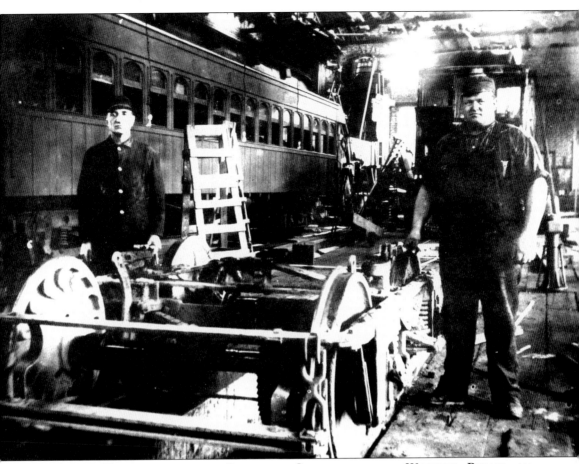

A PHOTO TAKEN INSIDE THE SHOPS AT GLOVERSVILLE AS WORKERS REPAIR AN INTERURBAN TRUCK. The large man on the right is Mr. Andrew Stoutner from Gloversville. He worked in the shops for many years.

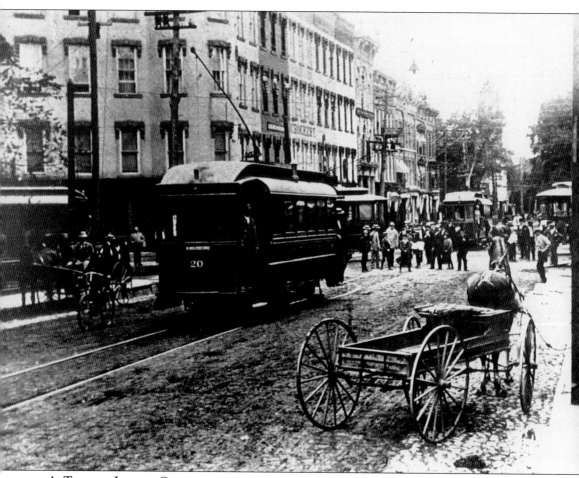

A Traffic Jam in Gloversville, early 1900s. Five electric cars converge on the four corners. This is not believed to be a photo stunt; someone must have had to reverse their car in order to clear the way.

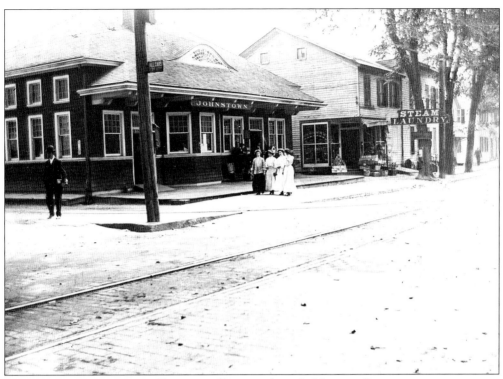

THE JOHNSTOWN ELECTRIC TERMINAL (STATION) ON S. MARKET STREET.

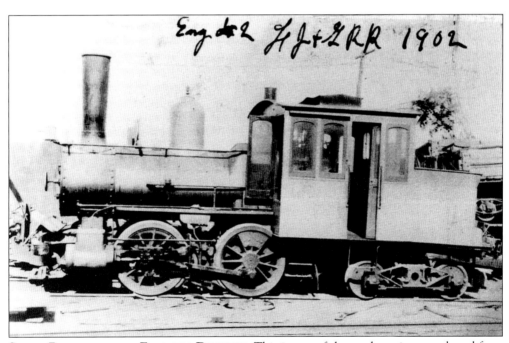

STEAM POWER FOR THE ELECTRIC DIVISION. This is one of the work engines purchased from the Manhattan Elevated Railroad in New York City to construct the FJ&G Railroad's Electric Division to Schenectady in 1903.

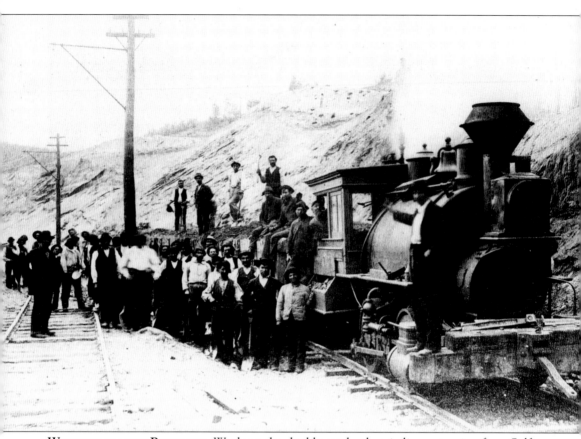

WORKING ON THE RAILROAD. Work on the double-track, electric line extension from Sulfur Springs Junction to Schenectady continued throughout 1902 and 1903. The FJ&G employed the use of several small steam engines during construction. In this photo an 0-4-0 saddle tanker is working with a large crew of laborers clearing right-of-way for the parallel track.

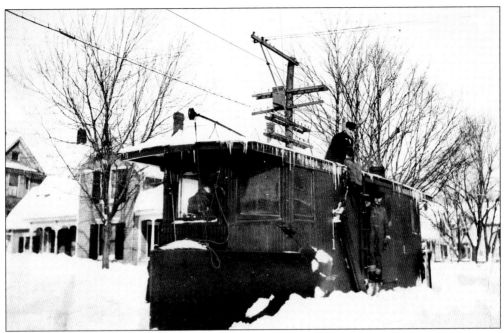

SNOWPLOW #1 STUCK IN THE SNOW SOMEWHERE ON THE FJ&G ELECTRIC DIVISION. Seated on top is Mr. Fred Dye, a motorman on the Electric Division for many years. Fred was responsible for preserving and producing many of the photos of the FJ&G Railroad's early history.

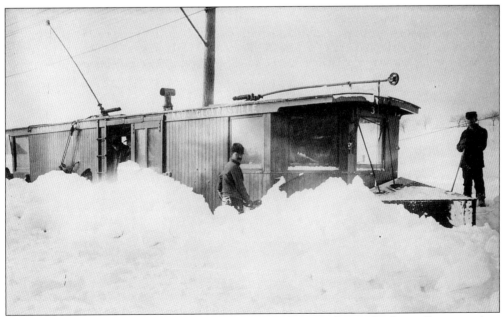

STUCK IN THE SNOW. The Electric Division suffered the same fate as the Steam Division when the winter snows came. Here, electric snow plow #3 seems hopelessly buried while the railroad crew digs by hand.

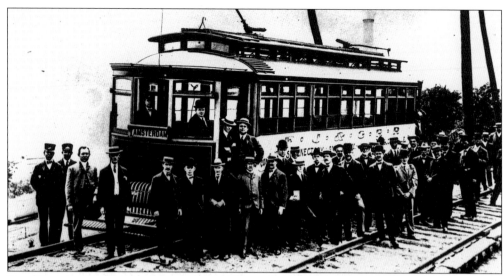

THE OFFICIAL OPENING OF THE DOUBLE-TRACK LINE FROM JOHNSTOWN TO SCHENECTADY. The opening took place in the summer of 1903. In the background the 170-foot high chimney of the Tribes Hill power plant towers over officials of the FJ&G and dignitaries from the area, posing in front of one of the cars recently purchased from the Lehigh Valley Transit Co. Without enough time to paint the FJ&G logo on these new cars, banners were hung on each side boasting of the connections served from Schenectady to Sacandaga Park. These cars would soon be numbered 75–82, and in later years would be called the "Fonda Cars" until service to Fonda was discontinued in 1932.

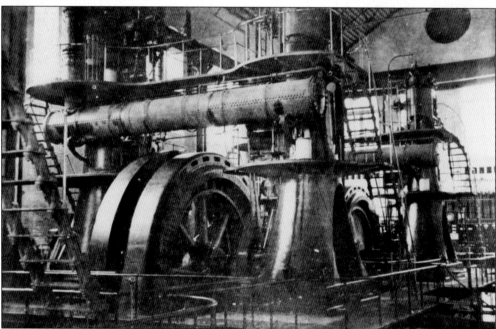

AN INTERIOR VIEW OF THE POWER PLANT AT TRIBES HILL IN THE SCENIC MOHAWK VALLEY. These massive steam-powered turbines produced 13,000 volts of electricity and relayed this current to three substations, one in Glenville near Scotia, one near the car barns in Amsterdam, and one at the old Cayadutta Electric Railroads powerhouse in Johnstown.

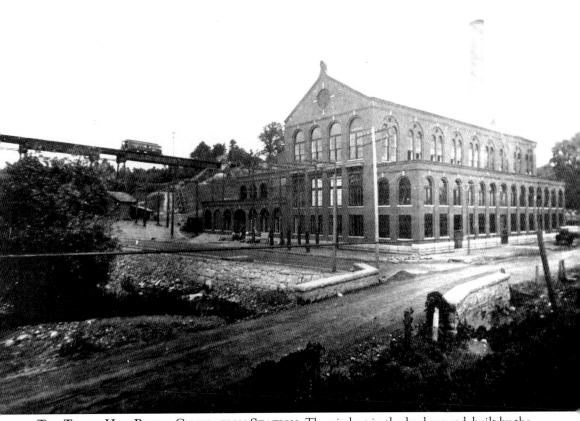

THE TRIBES HILL POWER GENERATION STATION. The viaduct in the background, built by the FJ&G Railroad, carried two tracks and their overhead wires 600 feet across the ravine and over 70 feet in the air.

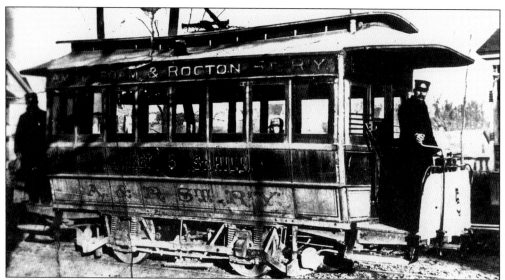

THE MARKET STREET CAR IN THE 1890S, AMSTERDAM.

DERAILED IN AMSTERDAM. Car #15 comes to rest on Main Street in Amsterdam early in January 1901.

90

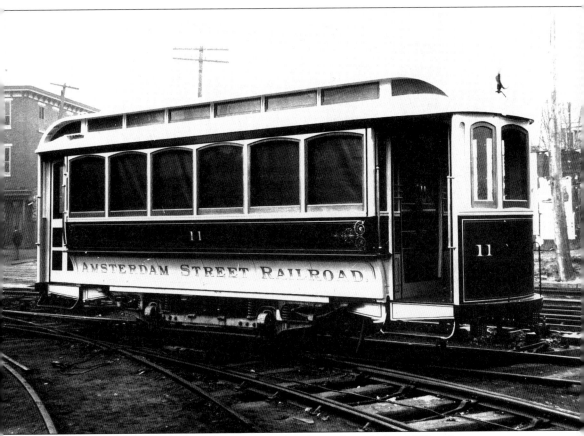

THE AMSTERDAM STREET RAILROAD. The railroad was electrified in 1890 and many cars were purchased in the following years. In this photo, #11 had just been delivered, dating this shot to 1895.

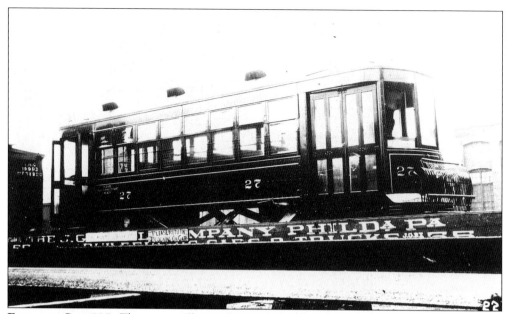

ELECTRIC CAR #27. The car is still on a flat car before being delivered to the FJ&G from the Wason Co. car builders in Massachusetts.

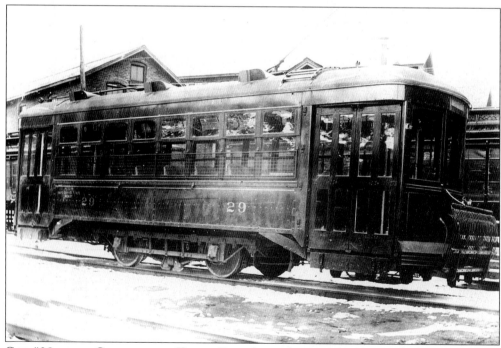

CAR #29 IN THE GLOVERSVILLE YARDS. Four identical cars, #26–#29, were built by the Wason Co. in Massachusetts.

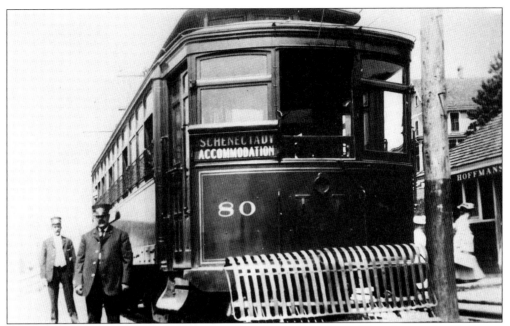

CAR #80 AT HOFFMANS. Passengers disembark from interurban #80 and enter the Hoffmans station, located halfway between Scotia and Amsterdam in the Mohawk Valley.

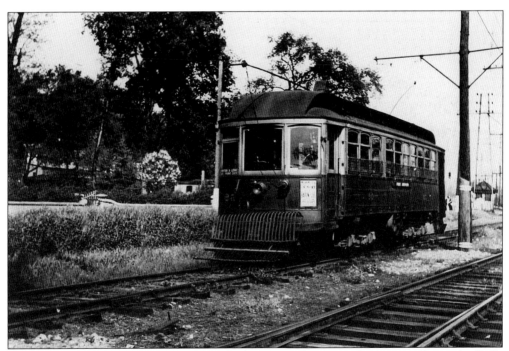

ENGINE #60. Not nearly as luxurious as the larger wooden interurbans nor as fast as the Brill-built "Bullets," interurban #60, a Fort Johnson car, saw many years of dependable service shuttling passengers through the Mohawk Valley.

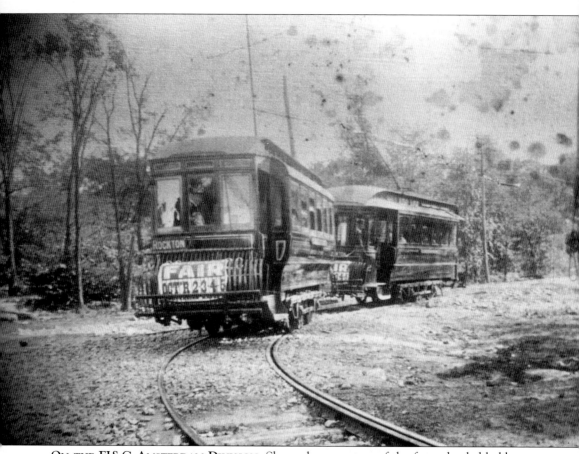

ON THE FJ&G AMSTERDAM DIVISION. Shown here are two of the four-wheeled bobber cars used on the Amsterdam Division to service Rockton and Hagaman. The photograph is believed to have been taken at the Jollyland Park near Rockton.

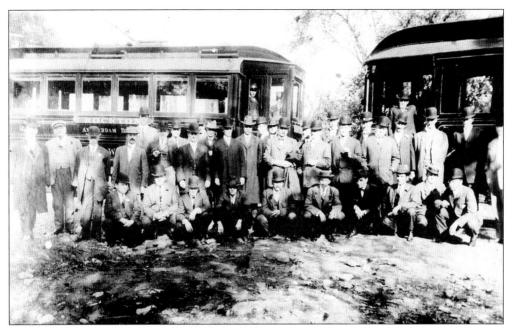

LOCAL DIGNITARIES AND FJ&G RAILROAD EXECUTIVES POSING FOR A PHOTOGRAPH ON THE FIRST OFFICIAL TRIP TO ROCKTON.

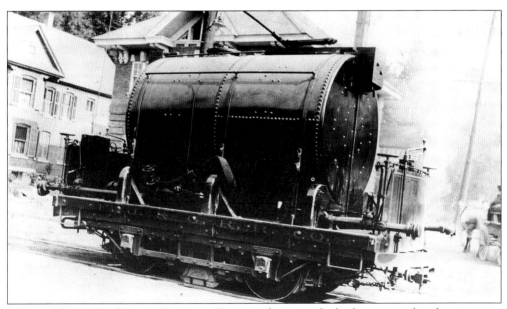

A BRILL COMPANY STREET SWEEPER. Keeping abreast with the latest in railroad equipment, the FJ&G ordered this newly constructed, self-powered, 2,500-gallon street sprinkler from the Brill Co. in 1911 for use in Amsterdam. Imagine driving a machine powered by electric motors under your feet that derive their power via a 600-volt DC wire overhead, while spraying water. The operators of this sprinkler did!

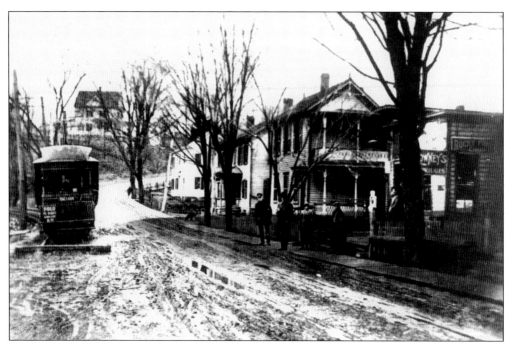

THE END OF THE LINE IN HAGAMAN. The small building to the right was the waiting room for the community of Hagaman on the Amsterdam division.

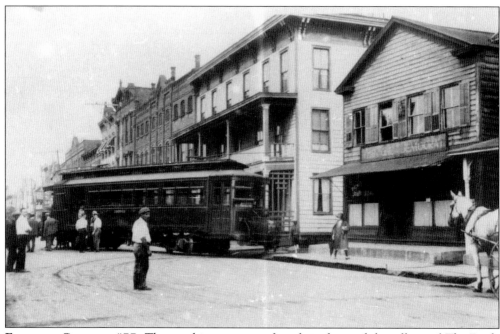

ELECTRIC COMBINE #77. The combine ran out of track in front of the offices of *The Fonda Democrat* on Main Street in Fonda.

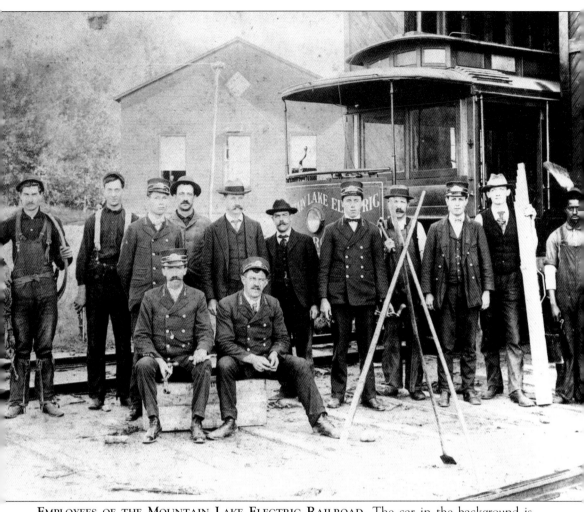

EMPLOYEES OF THE MOUNTAIN LAKE ELECTRIC RAILROAD. The car in the background is believed to be ill-fated car #1. Notice the line man (far left) and the control levers held by the motormen.

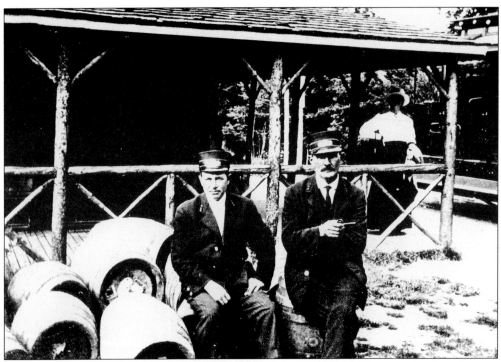

A Motor Car Operator and Conductor. Seated on what appear to be beer kegs at Mountain Lake, the two men wait for their car to fill with passengers.

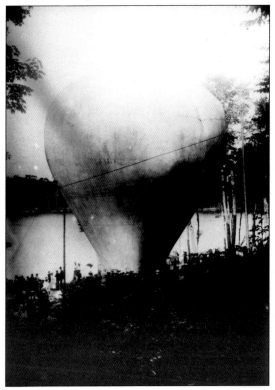

A Balloon Ascension. Like the Cayadutta Electric Railroad, the Mountain Lake Railroad tried to compete with Sacandaga Park and its attractions by staging events such as this balloon ascension, which took place next to the shores of Mountain Lake in the late 1890s.

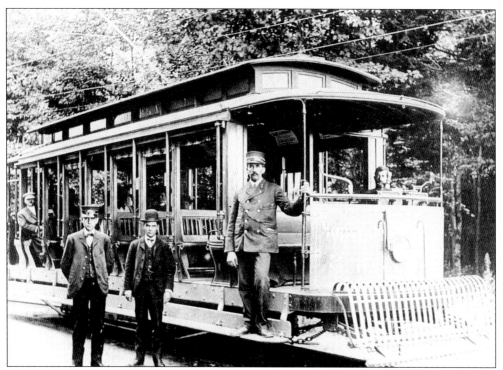

MOUNTAIN LAKE ELECTRIC CAR #2 AT MOUNTAIN LAKE, SEPTEMBER 1901. This resort was located a few miles from Gloversville near the small hamlet of Bleecker.

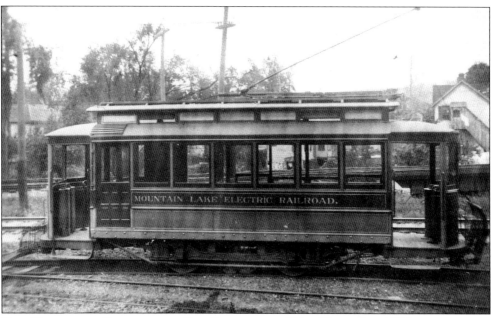

CAR #5 NEAR THE GLOVERSVILLE CAR BARN BEFORE "THE WRECK" IN 1902.

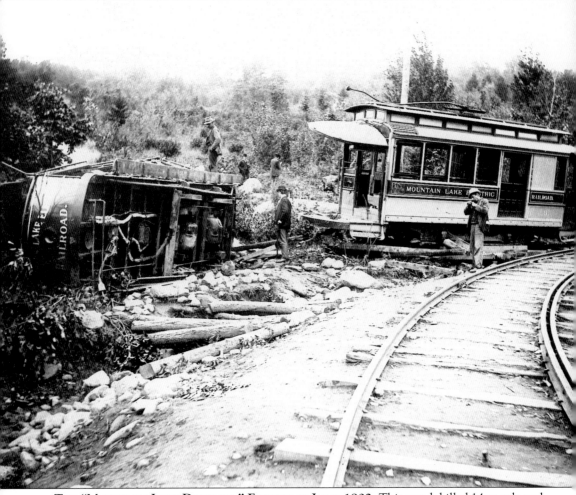

THE "MOUNTAIN LAKE DISASTER," FOURTH OF JULY, 1902. This wreck killed 14 people and injured many more. Late in the evening, after the fireworks display, two overloaded cars left the small amusement park and headed down the mountain. In the dark, heavier car #5 lost brake control and collided with smaller car #1 on a sharp curve. This disaster ultimately bankrupted the small company. Reorganization into the Adirondack Lakes Traction Company proved frivolous and the railroad was subsequently purchased by the FJ&G Railroad Co. in January of 1904.

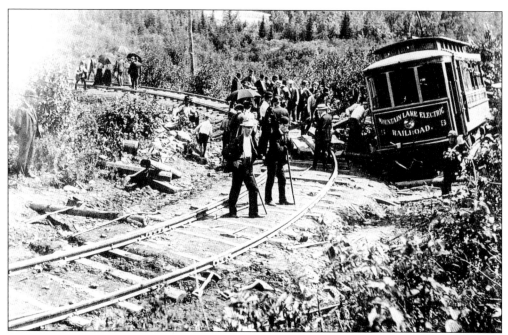

ANOTHER VIEW OF THE MOUNTAIN LAKE WRECK. For weeks after the tragedy occurred people walked up the mountain to see the site of the disaster.

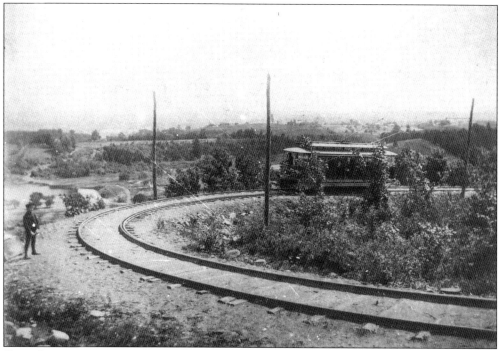

OPEN CAR #3 ON THE DEADLY CURVE NEAR MOUNTAIN LAKE THAT CLAIMED 14 LIVES.

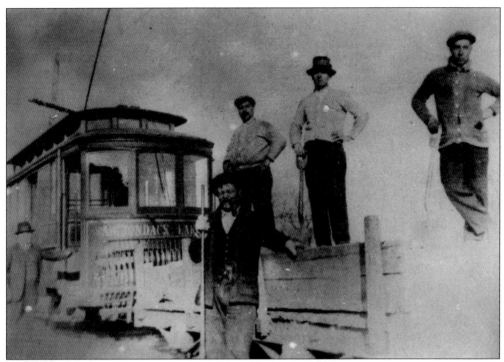

THE ADIRONDACK LAKES TRACTION COMPANY. The reorganization into the Adirondack Lakes Traction Company, in May of 1903, was short-lived. In less than a year this second attempt to save the Mountain Lake Railroad and the resort would be sold outright to the FJ&G Railroad. Only a handful of pictures remain of this endeavor.

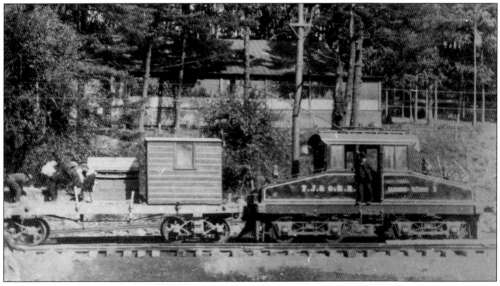

STEEPLE CAB ELECTRIC #1 AT MOUNTAIN LAKE SOON AFTER THE **FJ&G** PURCHASE.

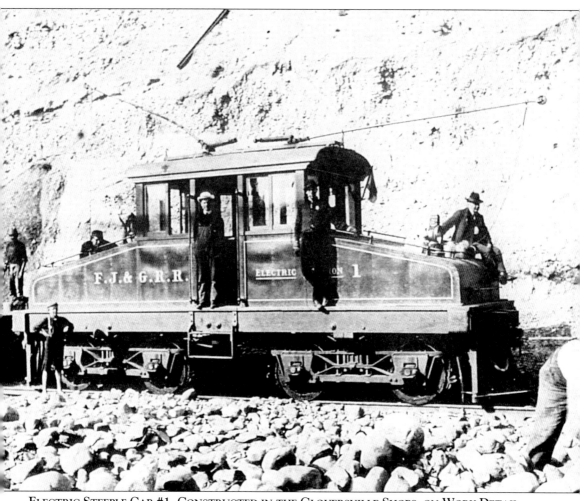

ELECTRIC STEEPLE CAB #1, CONSTRUCTED IN THE GLOVERSVILLE SHOPS, ON WORK DETAIL.
This engine was later renumbered to #10, for reasons unknown.

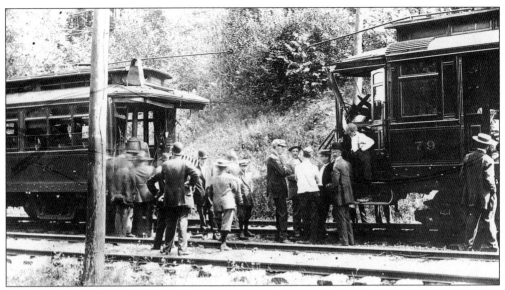

CAR #76 AND #79. The two cars collided in 1909 at Cayadutta Park.

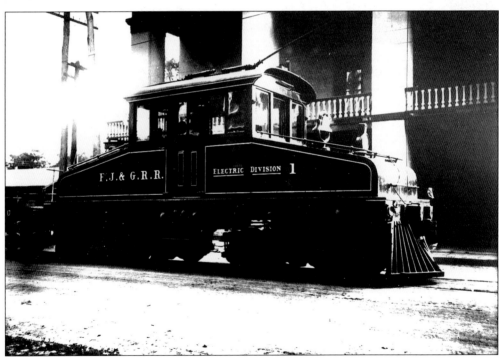

HOME-BUILT LOCOMOTIVE POWER. Motive power for the FJ&G Railroad's Electric Division was not always purchased. Using Taylor MCB trucks and motors from GE, the Gloversville shops produced this steeple cab locomotive in 1903. The locomotive is shown here in Fonda in front of the Hotel Roy.

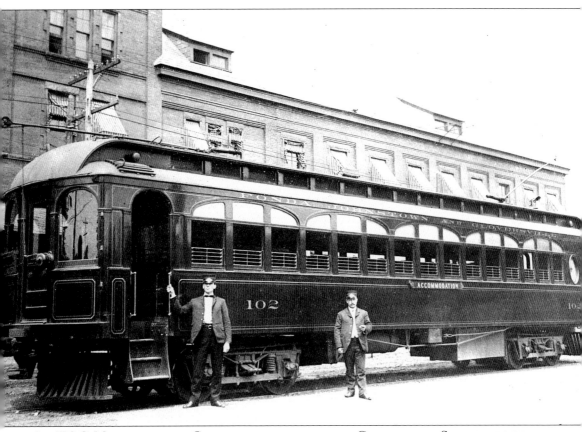

AN FJ&G MOTORMAN AND CONDUCTOR POSING AT THE GLOVERSVILLE STATION WHILE WAITING FOR PASSENGERS TO BOARD.

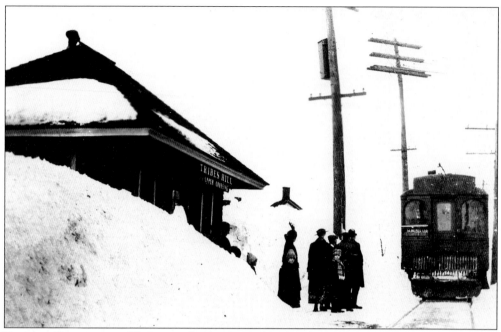

PATIENT PASSENGERS. With snow banks above their heads, passengers await the arrival of an electric car during the winter of 1916 at the Tribes Hill station, constructed in 1903.

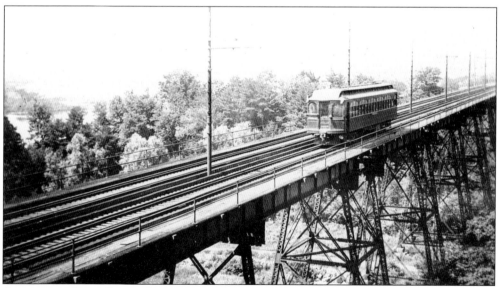

ONE OF THE SAINT LOUIS CARS ON THE NEWLY CONSTRUCTED TRESTLE NEAR TRIBES HILL IN 1904.

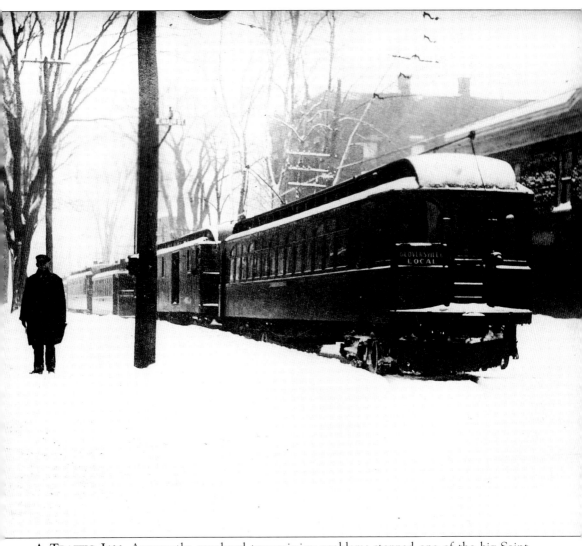

A TRAFFIC JAM. Apparently, overhead transmission problems stopped one of the big Saint Louis cars and traffic quickly piled up behind on S. Perry Street, near the corner of Main Street in Johnstown.

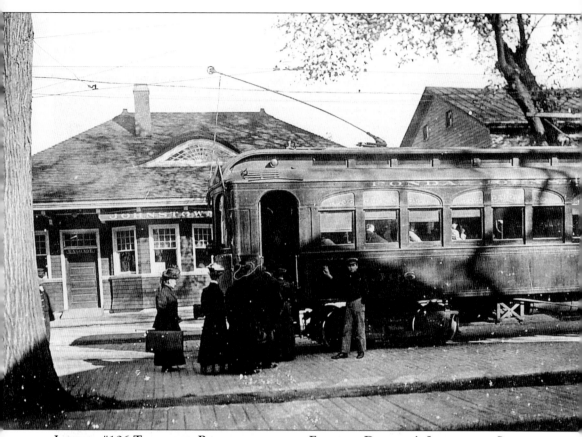

LIMITED #106 TAKING ON PASSENGERS AT THE ELECTRIC DIVISION'S JOHNSTOWN STATION. The Saint Louis Car Company built a total of 12 of these impressive interurbans in 1903 and 1904 for the FJ&G, costing some $14,000 each. This railroad spared no expense for its passengers' comforts. In 1904 these cars were the very best that money could buy.

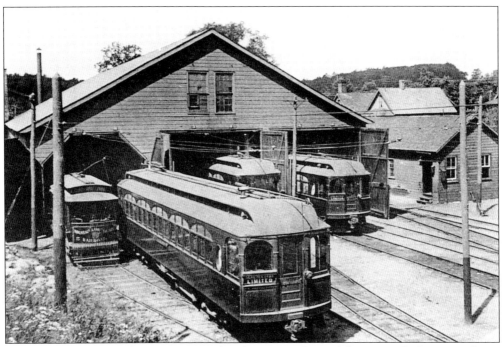

St. Louis Cars. Dwarfing Mountain Lake Electric #2, three of the ornate St. Louis cars leave the car barns in Gloversville for the day's run.

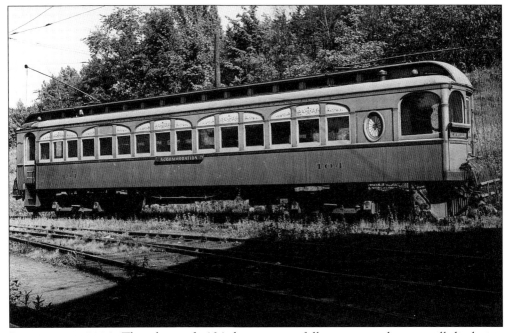

Interurban #104. This photo of #104 shows a gracefully aging wooden car still displaying some of its fine frosted glass in the triple-arched windows and heated glass in the oval window that illuminated the restroom.

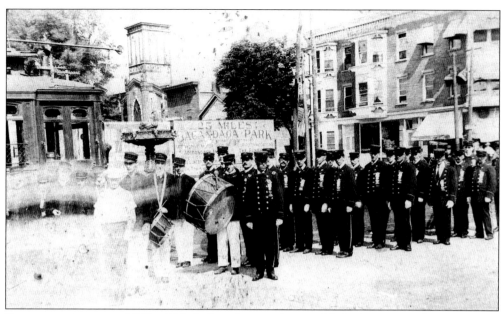

FONDA IN THE EARLY 1900S. This fading photograph most likely shows a men's organization from somewhere in the Mohawk Valley heading to Sacandaga Park for the day. Note the fountain behind the man carrying the snare drum and the billboard sign advertising 25 miles to Sacandaga Park.

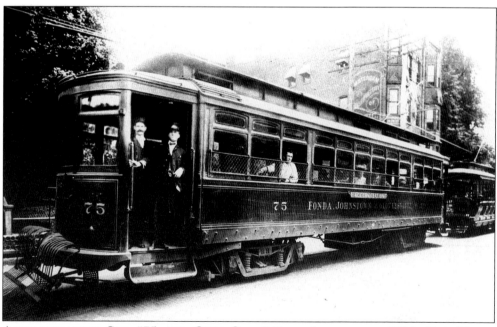

ACCOMMODATION CAR #75 AND OPEN CAR #42 IN AMSTERDAM, 1904. Car #75 was purchased from the Lehigh Valley Transit Co.

110

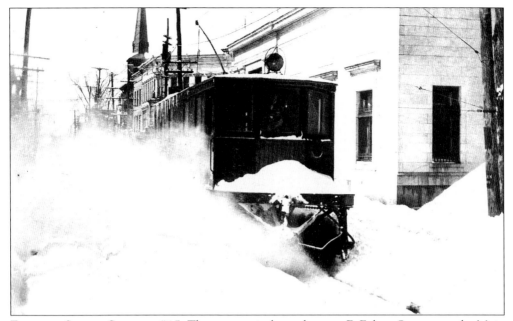

ELECTRIC STREET SWEEPER #15. The sweeper is shown here on E. Fulton Street near the Main Street intersection on March 16, 1916.

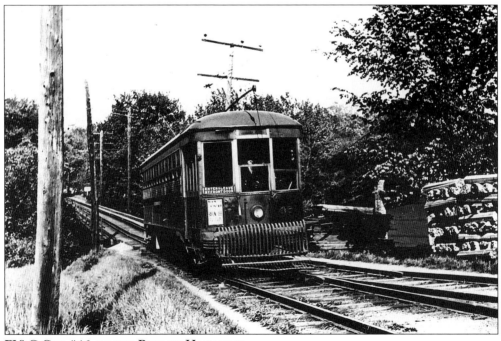

FJ&G CAR #46 ON THE RUN TO HAGAMAN.

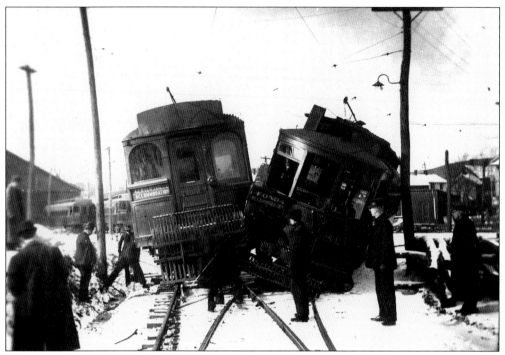

A TRAIN WRECK. The larger Gloversville accommodation car, on the left, appears to have run into the smaller Fonda car #82, on the right, on the "Y" track in front of the Gloversville car barns.

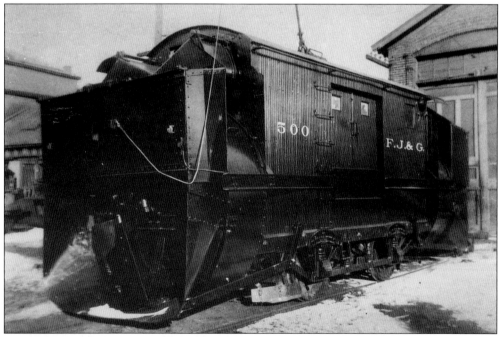

TWO IDENTICAL ROTARY SNOWPLOWS, #500 AND #501. These snowplows were purchased in 1920 for use on the Electric Division. They were soon sold after the railroad realized they would not clear a path wide enough for some of the larger interurbans.

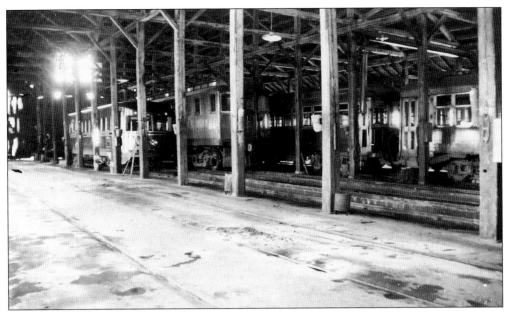

A VIEW OF THE INTERIOR OF THE CAR BARNS. The barns were located near the intersection of S. Main Street and Broad Street in Gloversville. One of the Brill bullet cars is parked over the work pit.

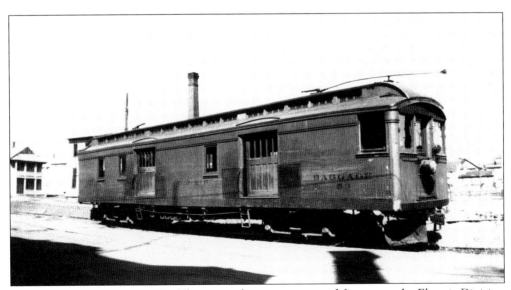

ELECTRIC BAGGAGE CAR #53. This interurban was converted for use on the Electric Division by the Gloversville shops in 1919. It was constructed using baggage car #60 from the FJ&G Steam Division.

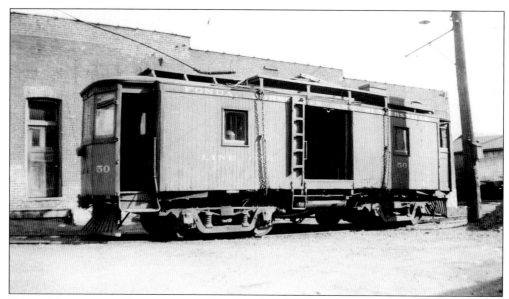

CAR #50 IN LATER YEARS, AFTER ITS CONVERSION INTO A LINE CAR FOR THE FJ&G ELECTRIC DIVISION. This car was equipped with benches for use by local leather workers, who worked with odorous chemicals during the tanning process.

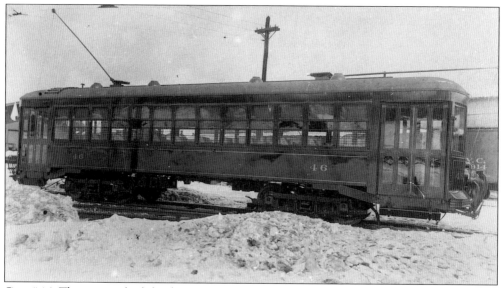

CAR #46. This car was built by the Wason Car Co. in 1924. It is shown here posing for a winter photo. Two cars of this type, #45 and #46, were purchased.

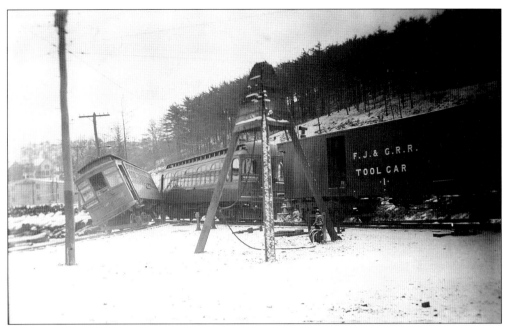

ANOTHER VIEW OF THE COLLISION AT THE "Y." This photograph shows the same accident on p. 112 from a different angle. In the background is the Gloversville Knitting Co., later called the Continental Mill. During the late 1930s the boiler that was used to heat this mill exploded and engine #12 (below), nearing the end of its useful life, had the undignified duty to provide heat for the mill during the winter.

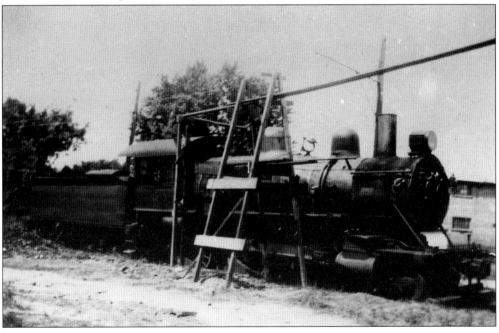

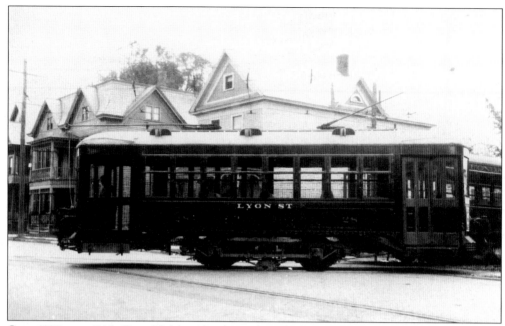

CARS #28 AND #45. Car #28 (above) was purchased in 1917 from the Wason Co. for service on the Amsterdam Division. Car #45 (below) was also built by the Wason Co. but with a larger seating capacity to replace the earlier car. It is shown here filled to capacity in Amsterdam.

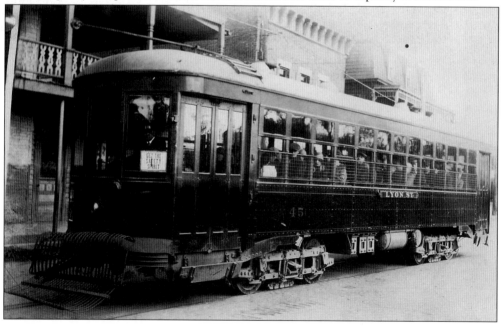

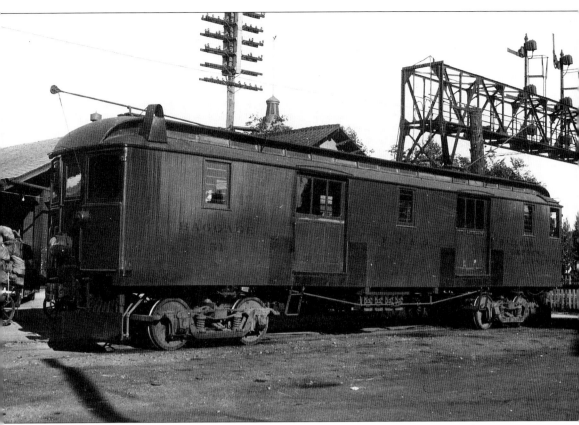

BAGGAGE CAR #51 IN FONDA. Unlike homemade baggage car #53, #51 and #52 were purchased from the Saint Louis car shops in 1904. This photograph shows #51 at the station in Fonda, well maintained, having served for more than 30 years.

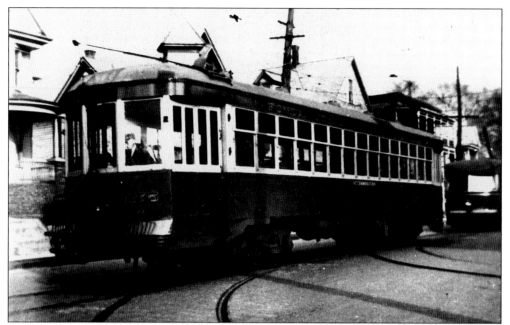

CAR #175 IN AMSTERDAM, BEING CHASED BY ONE OF THE NEW BRILL "BULLET CARS."

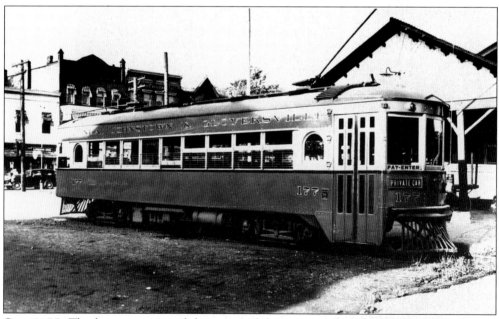

CAR #177. The last in a series of three cars of this type purchased in 1924, #177 waits for passengers at the Fonda station.

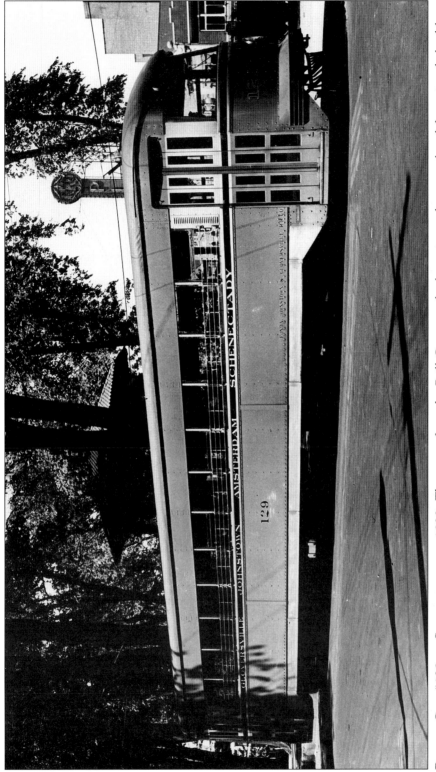

BULLET CAR #129 IN SCHENECTEDY IN 1933. These cars from the Brill Co. were the latest in modern travel and for a time helped keep passenger traffic with the railroad.

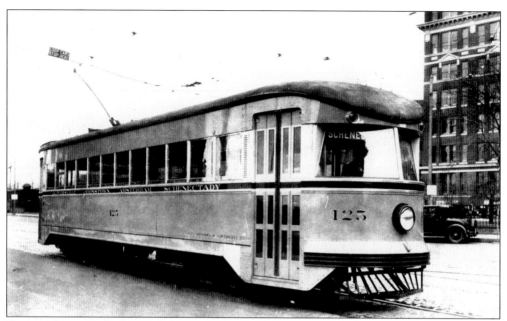

Bullet Car #125, soon after Delivery to the FJ&G, in Schenectady on March 7, 1932.

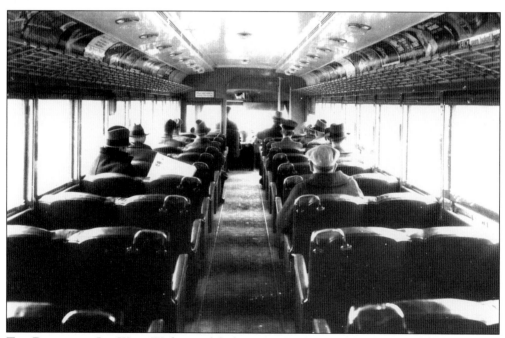

THE BULLET ON ITS WAY. With a qualified operator at the controls, these gentlemen, dressed for winter, are being speedily delivered to their destinations in a whisper-quiet "Bullet."

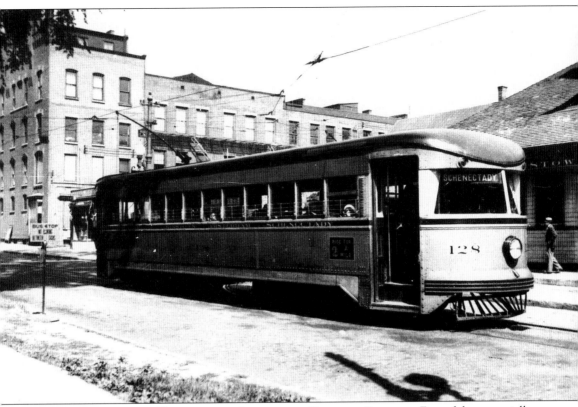

Interurban #128 in Front of the Johnstown Electric Station. Five of these specially designed, high-speed interurbans built by the Brill Co. and numbered 125–129 were delivered to the FJ&G Railroad in 1932. Nicknamed "bullet cars" because of their streamlined shape and high speed, these cars were an attempt to regain some of the Schenectady passenger traffic lost to the automobile and buses. This valiant yet somewhat costly effort worked for a time, but with the condemnation of the Mohawk River Bridge into Schenectady in 1936 passenger traffic soon dwindled, ultimately causing the line's abandonment by 1938.

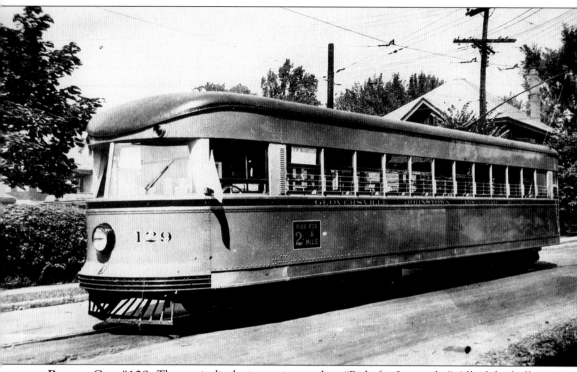

BULLET CAR #129. The car is displaying a sign reading "Ride for 2¢ a mile." All of the bullet cars were sold to the Bamberger Railroad in Utah in 1939, where they remained until 1952. Car #127 was salvaged by the Orange Empire Museum in Perris, California, and is currently being restored to operating order.

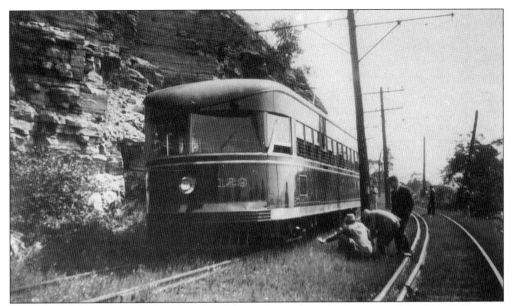

INTERESTED ONLOOKERS. A group of rail fans takes a closer look at one of the Brill bullet cars after it stopped at the scenic Hoffmans Cut in the Mohawk Valley for a photo opportunity.

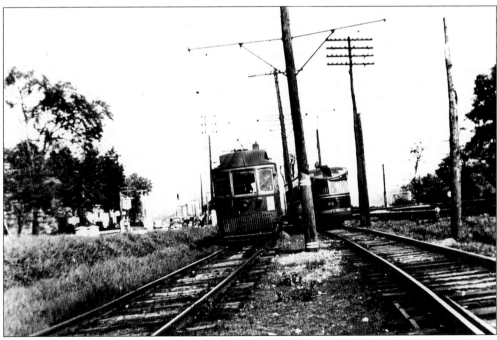

INTERURBAN #60 AND BULLET CAR #125 BETWEEN HIGHWAY ROUTE 5 AND THE MAIN LINE OF THE NYCRR AT FORT JOHNSON. Several people the author has interviewed remember high-speed races between the bullet cars, autos, and steam engines heading through the Mohawk Valley between Schenectady and Amsterdam.

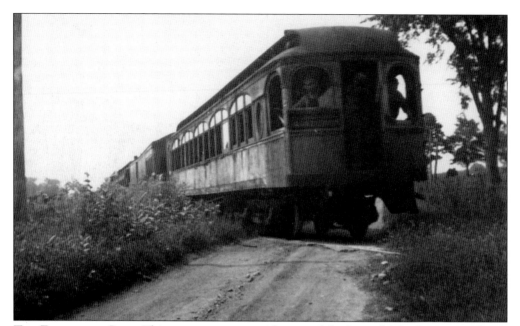

THE END OF THE LINE. This was a one-way trip for one of the beautiful St. Louis cars, shown here on its way on the Broadalbin line to be burned.

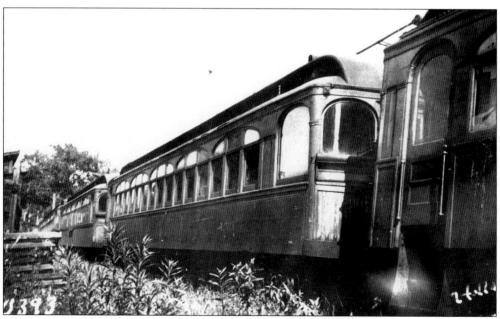

SEVERAL OF THE WOODEN INTERURBANS. The cars are awaiting the wasteful practice of incineration near the car barns in Gloversville.

LAST TRIP FOR #177. A Gloversville policeman stands watch at the busy four corners intersection as passengers board FJ&G interurban #177, late in the afternoon of June 27, 1938, for one of the last runs made to Scotia. The Electric Division was officially closed the next day.

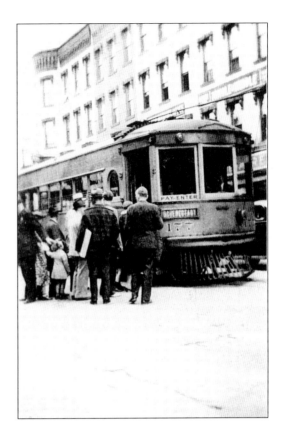

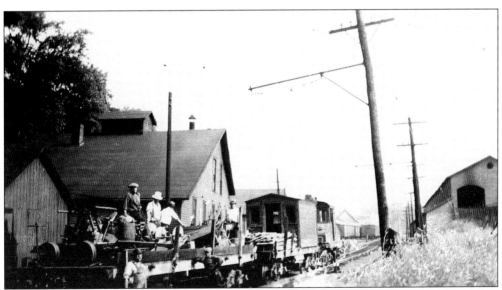

LAST DAY FOR THE ELECTRIC DIVISION. Steeple cab electric #10 brings a salvage train home to the Gloversville yards on June 28, 1938. Later that night car #176 made the last run to Schenectady and returned early in the morning of June 29. The electric current was then shut off.

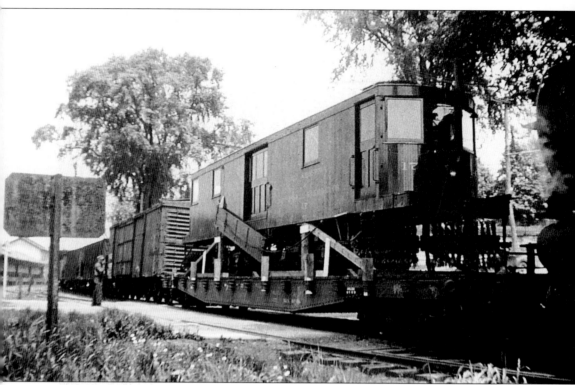

SHUFFLING OFF TO BUFFALO. Street sweeper #17 has been loaded on a flat car and is headed to Buffalo for use on that city's transit system. It was a common sight in 1938–39 to see electric equipment shipped in this manner, as the electric line had been abandoned and much of its equipment sold.

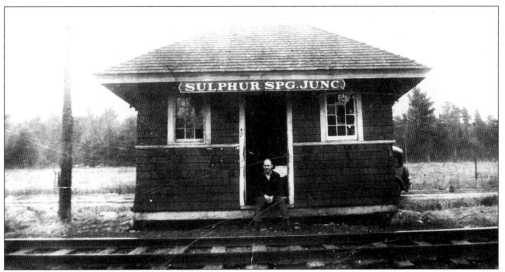

THE SULPHUR SPRING JUNCTION DEPOT IN 1938, ON THE ELECTRIC DIVISION. After leaving Johnstown the road split at this location; the right traveled over the hill and into Fonda, and the left went on through Tribes Hill and into the Mohawk Valley, heading for Amsterdam and its terminus at Schenectady.

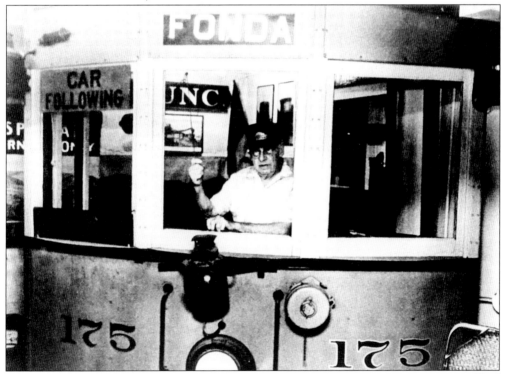

MR. ROBERT BEDFORD OF JOHNSTOWN INSIDE THE CAB OF INTERURBAN #175. Mr. Bedford salvaged the car and displayed it in the cellar of his home in Johnstown for many years. As a child I accompanied my father to Mr. Bedford's home to see his model railroad layout. The control lever from #175 was cleverly converted to control the 0 gauge electric railroad built around the cellar.

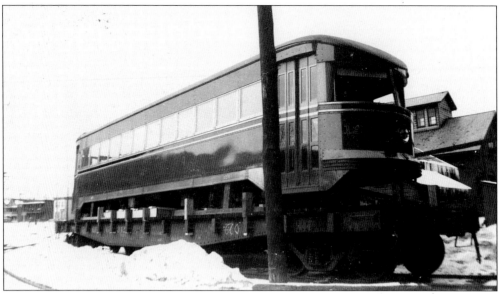

BULLET CAR 127. The car is being loaded on a flat car in September 1939, for delivery to the Bamberger Electric Railroad in Utah, where it remained in service until 1952.

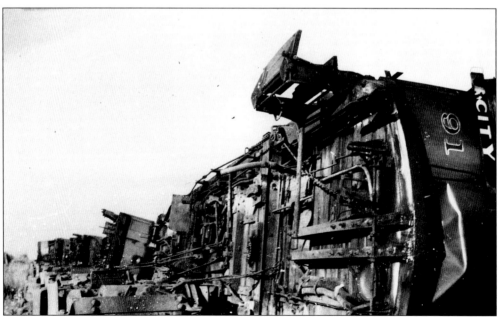

ELECTRIC CARS TOPPLED AND WAITING TO BE BURNED ON THE BROADALBIN LINE. The practice of burning equipment was commonplace on the railroads, as this was the easiest way to eliminate outdated equipment and salvage the scrap metal that remained after the fires cooled.